THINGS COME APART

2.0

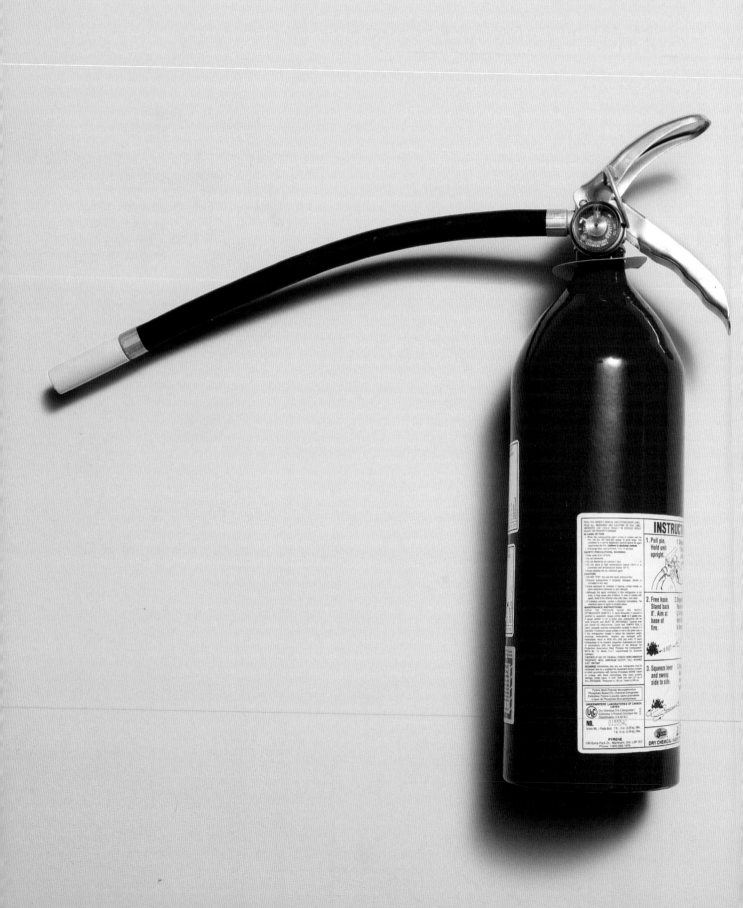

THINGS COME APART

2.0

A TEARDOWN MANUAL FOR MODERN LIVING

Todd McLellan

Thames & Hudson

with 123 colour illustrations
and 27,787 components

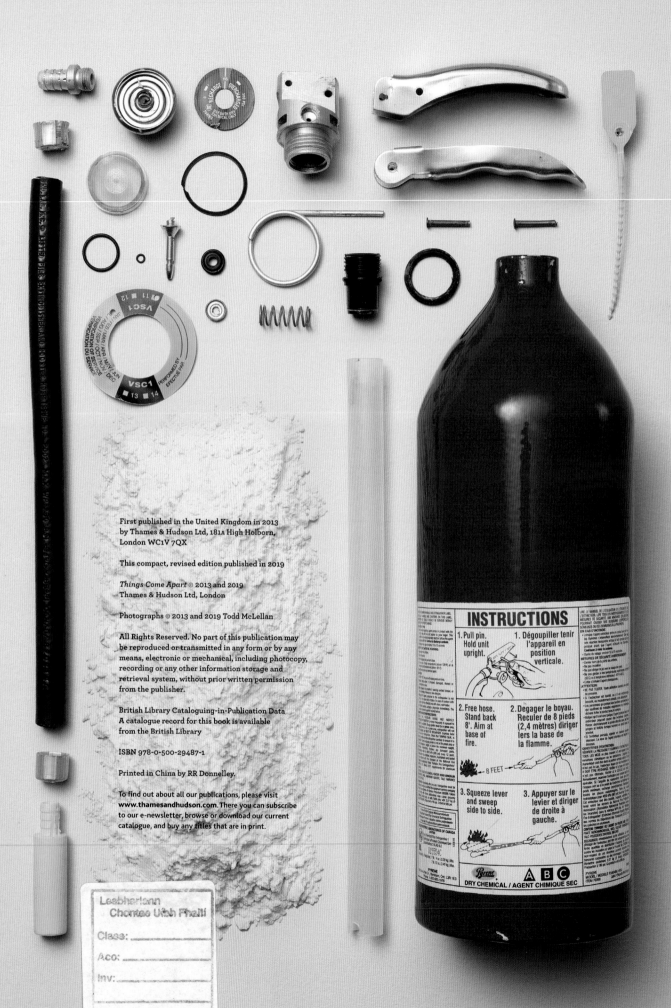

First published in the United Kingdom in 2013
by Thames & Hudson Ltd, 181A High Holborn,
London WC1V 7QX

This compact, revised edition published in 2019

Things Come Apart © 2013 and 2019
Thames & Hudson Ltd, London

Photographs © 2013 and 2019 Todd McLellan

British Library Cataloguing-in-Publication Data
A catalogue record for this book is available
from the British Library

ISBN 978-0-500-29487-1

Printed in China by RR Donnelley.

To find out about all our publications, please visit
www.thamesandhudson.com. There you can subscribe
to our e-newsletter, browse or download our current
catalogue, and buy any titles that are in print.

CONTENTS

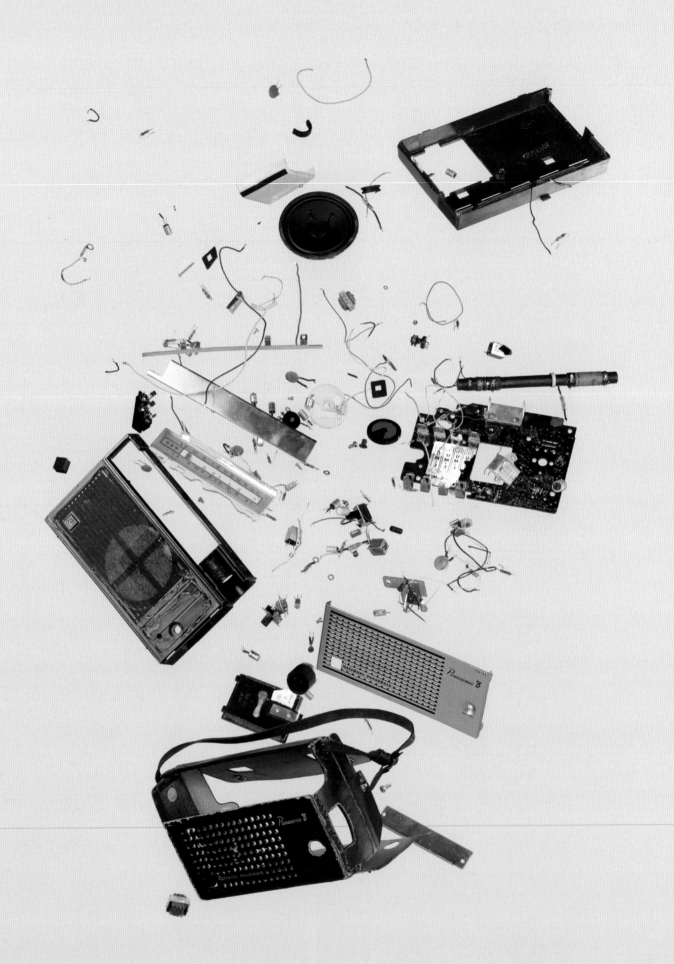

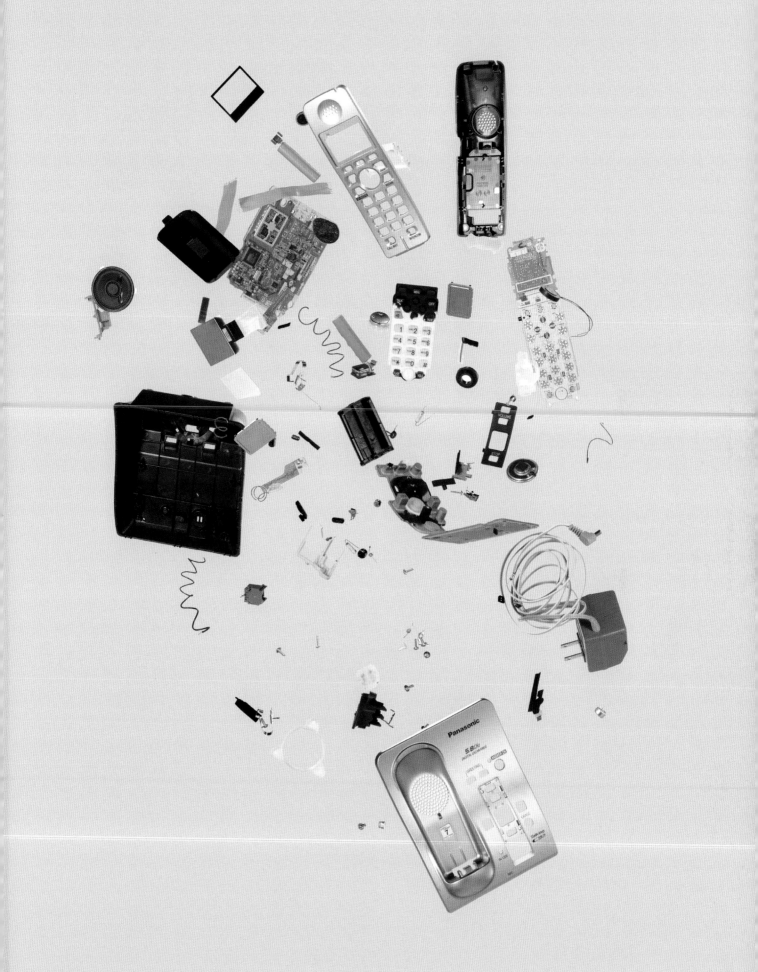

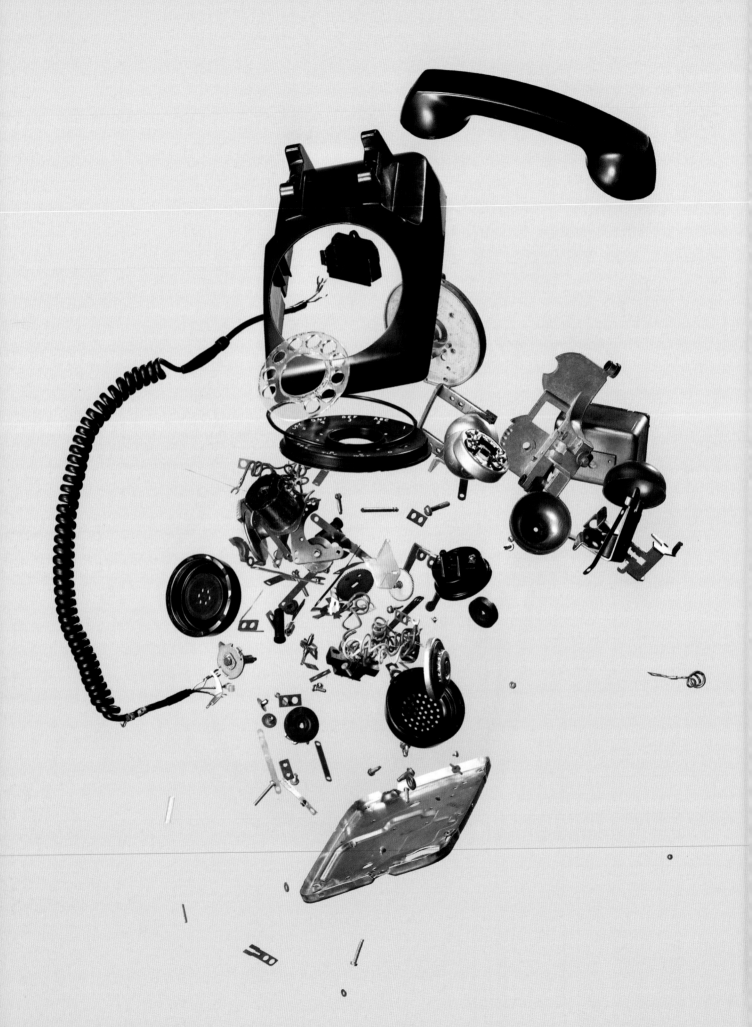

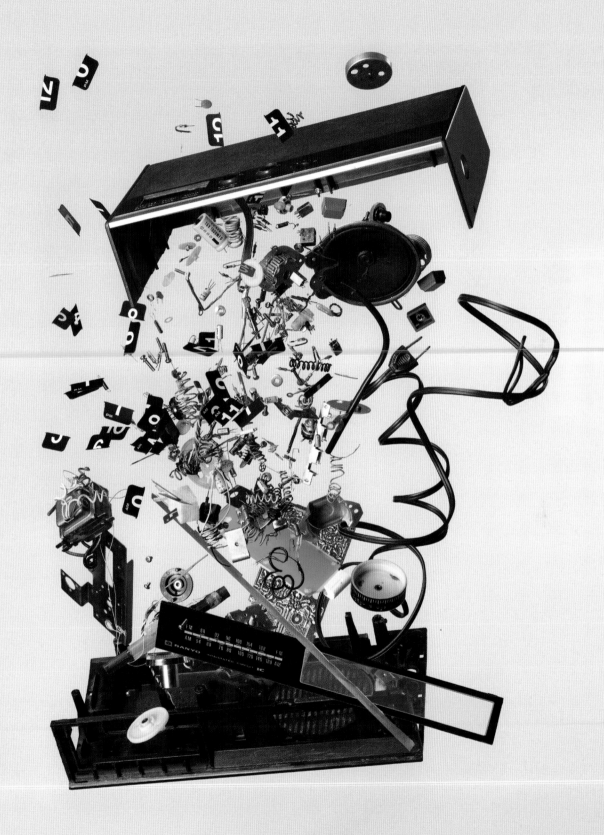

WE ALL HAVE ADHD THESE DAYS...

Todd McLellan

New objects become old objects faster than ever before. The waste and expense of having to replace everything in your life after just a few years of use is exasperating.

The new 'teardown' movement in technology challenges our disposable culture by exposing just what we are throwing away. For me, this has been a decades-long project; I have been refining the art of disassembly since childhood. As a kid, I was caught in my room taking apart my toys with a hammer, and in secondary school I almost completely disassembled my 1985 Hyundai Pony car. If an object interested me, it would soon be in pieces.

Since the hugely successful first publication of this book, the 'teardown' movement has continued to progress, and I have had the privilege to work on multiple exciting new projects, twelve of which have been included in this new and improved second edition. The interest of agencies, magazines, and manufacturing companies in my work has given me the opportunity to explore their engineered masterpieces, and create new compositions based on the art of knolling (positioning objects at parallel and perpendicular angles to create a visually appealing arrangement). I am especially thrilled that *Things Come Apart* has also been developed into a travelling exhibition, which will tour North America.

For this book, I have taken apart fifty design classics, including brand-new modern objects and vintage items that are no longer widely used. All of the objects that I disassembled for these photographs were in working order or needed little care to resuscitate them. It fascinates me that older objects were so well built, and were most likely put together by hand. These items were repaired when broken, not discarded like devices today. Older objects were created to give service and enjoyment for many years, but the technology that replaces them will itself be replaced even more rapidly. I wanted to get inside these once treasured objects and show the world their quality and beauty. This updated edition captures the wonder of how things come apart better than ever, showcasing brand new projects, a greater quality of deconstructed object and an even higher total component count.

When dismantling objects, I organize the pieces in separate containers in the sequence in which they are removed. For example, when dismantling a phone, all the headset pieces stay together in one tray and the ringer pieces in another. The thrilling part about disassembling an object myself, is the opportunity to understand the manufacturer's challenge. I gain a basic understanding of how the item works and, in turn, a greater respect for it.

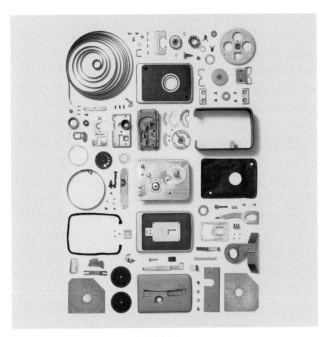

Brownie Movie Camera, 1960 | Kodak | Component count: 94

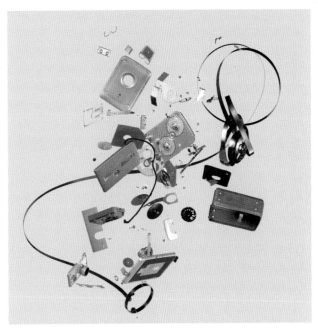

Brownie Movie Camera (exploded), 1960 | Kodak | Component count: 94

When everything is finally separated, I begin arranging the elements on a neutral background. Unless I am doing a 'drop' – a description of which follows – each object I disassemble is laid out in the same fashion. First, I position the main component, usually the exterior shell. After that, placing the parts in a beautiful shape is a bit of a puzzle, and I repeatedly rework the layout to make each piece fit in the space. If it takes one-and-a-half days to take an object apart, it takes just as long, if not longer, to lay it all out and achieve the right composition.

Even the smallest objects take three days or more. What comes in a tiny case may fill a surface 3 metres square, (32 square feet) so anticipating the size of the spread in advance is very difficult. This is especially true with the latest technology. As manufactured objects have evolved, they have become far more complex. Components are becoming more numerous, even as they decrease in size. The full size of the disassembly, with every single component laid out, can be huge in relation to the original object. It is as if the true scale of the object is revealed only when it is taken apart.

The objects in this book were photographed in two ways. In the first – mentioned above – I stayed faithful to the assembly and tried to lay out the pieces in the order in which they were revealed. This creates an image that is quite precise and formal, almost like a family portrait.

I think of the second method as setting the parts free. The pieces are placed on a platform near the ceiling, then dropped. They are arranged so that, as they fall through the camera frame, their appearance conforms closely to what I envisaged. Using the newest and fastest strobe-lighting technology, I am able to freeze the pieces mid-frame. Originally I tried to capture all of the falling pieces in a single shot, but since then I have had more success dropping the pieces in groups and then layering the resulting images in post-production. At first I tried light triggers to set off the camera and flash, but now I get the best results by watching the pieces fall and pressing the shutter at the precise moment that I see something exciting happen.

Things Come Apart has been an exercise in discovery, and I am thrilled how far it has come and the incredible reception it has received since its inception in 2009. I am not sure where this endeavour will end or what I will tackle next, but I hope you enjoy exploring the journey so far.

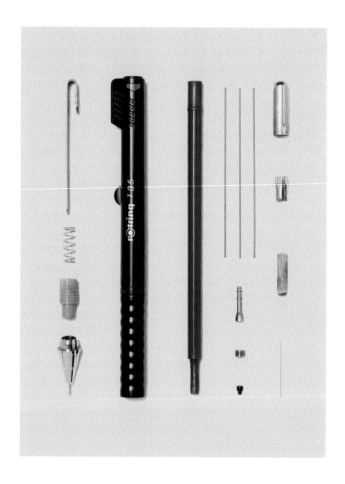

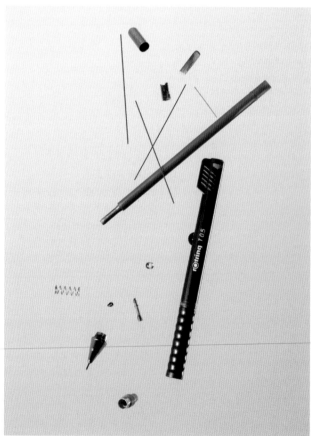

Mechanical Pencil, 1997

Rotring
Component count: 16

Stapler, 2002

Isaberg AB
Component count: 31

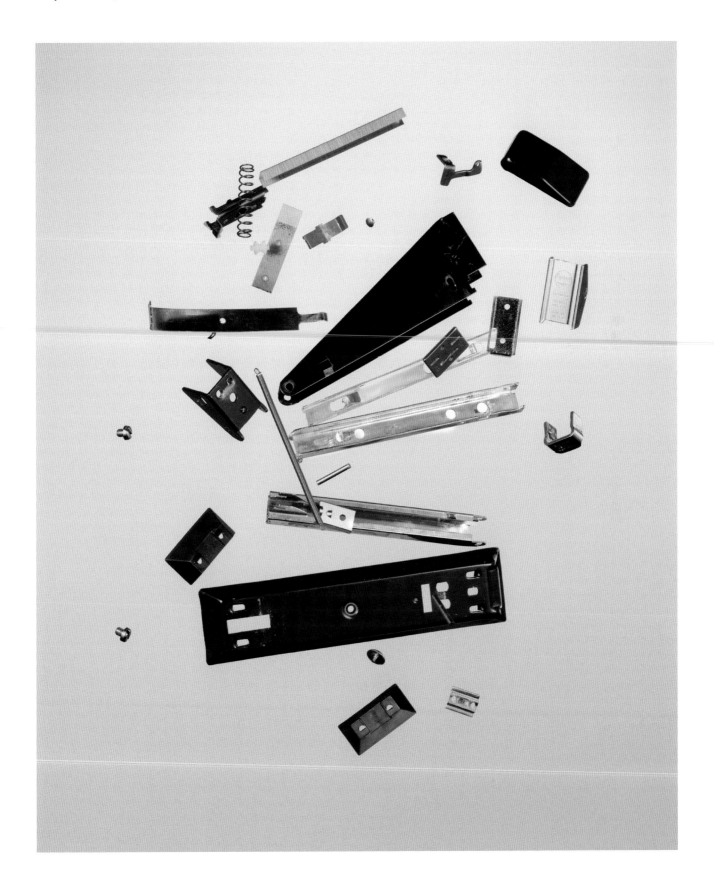

Compact Cassette, 1985
RCA
Component count: 24

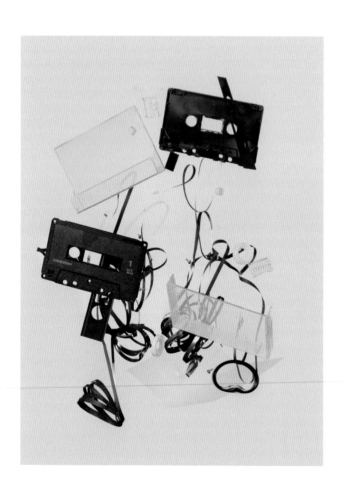

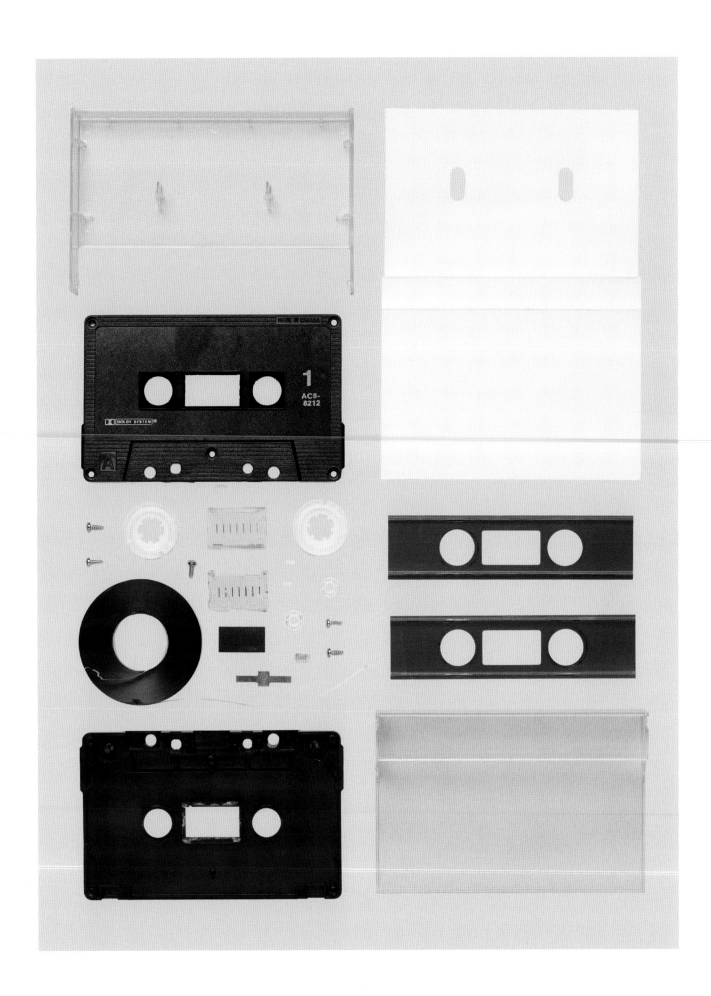

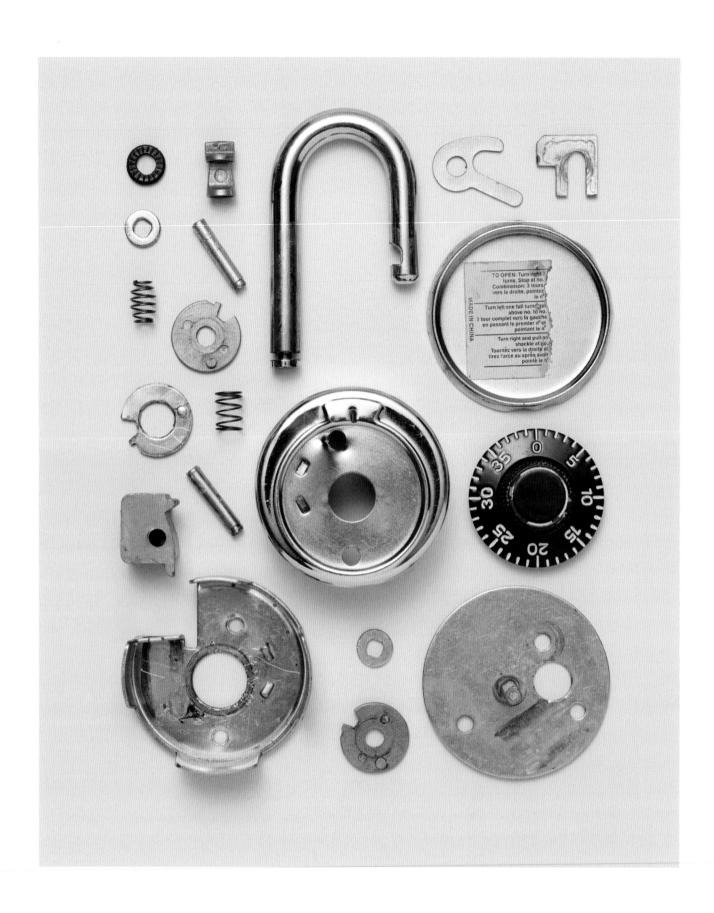

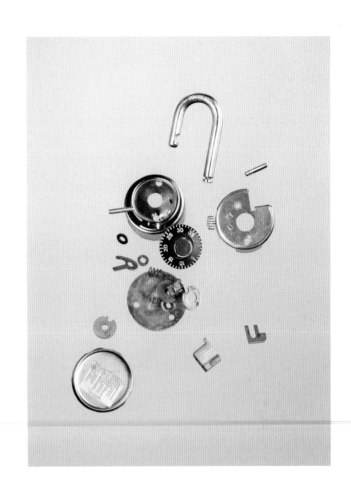

Dial Combination Lock, 2000s

CJSJ
Component count: 20

Digital Watch, 2010

Raised By Wolves/Furni
Component count: 57

Mechanical Watch, 1990s

Vostok
Component count: 130

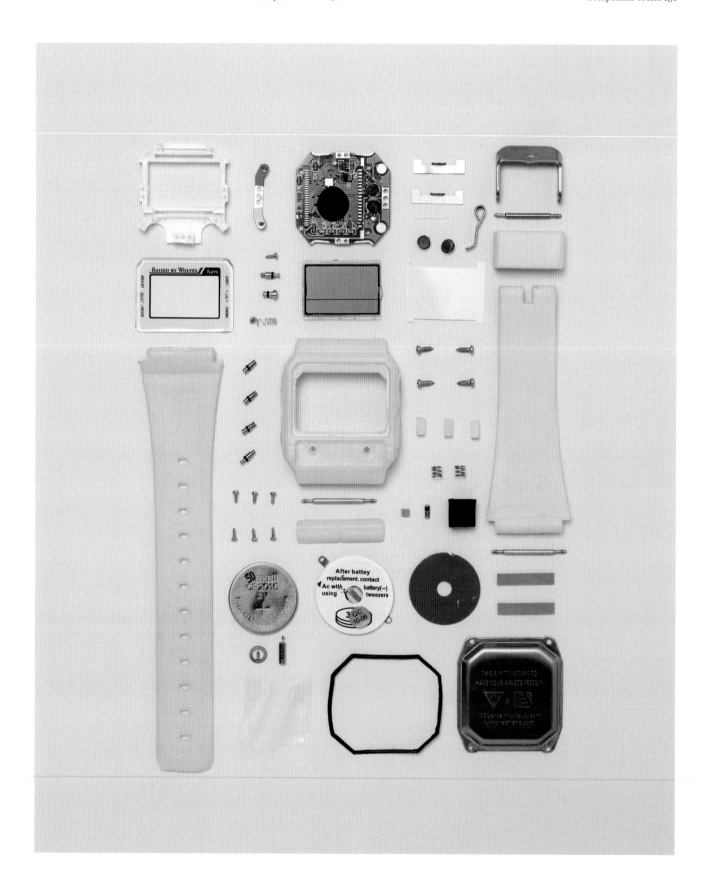

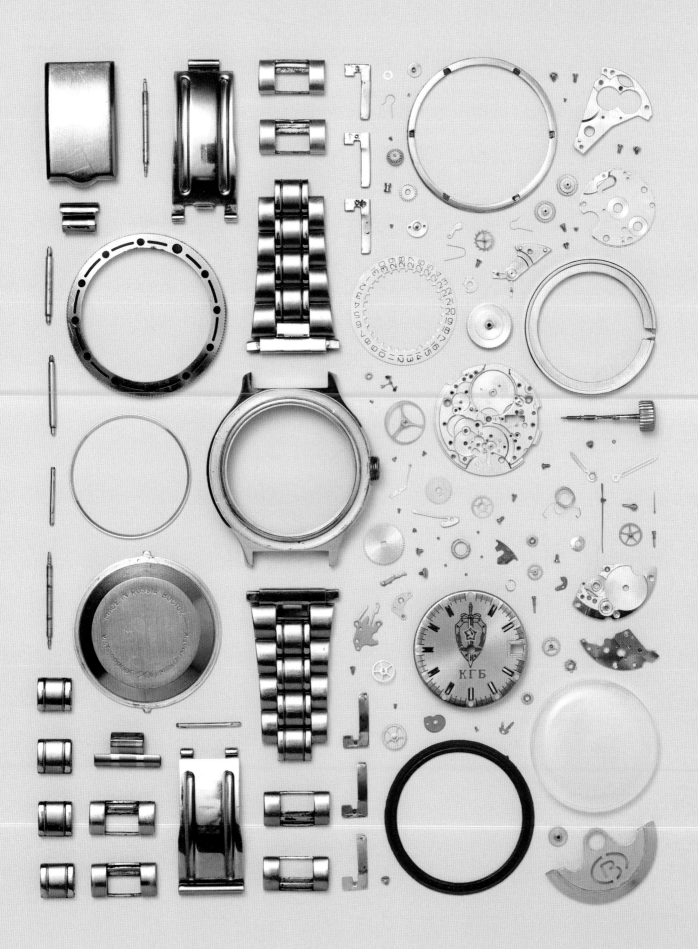

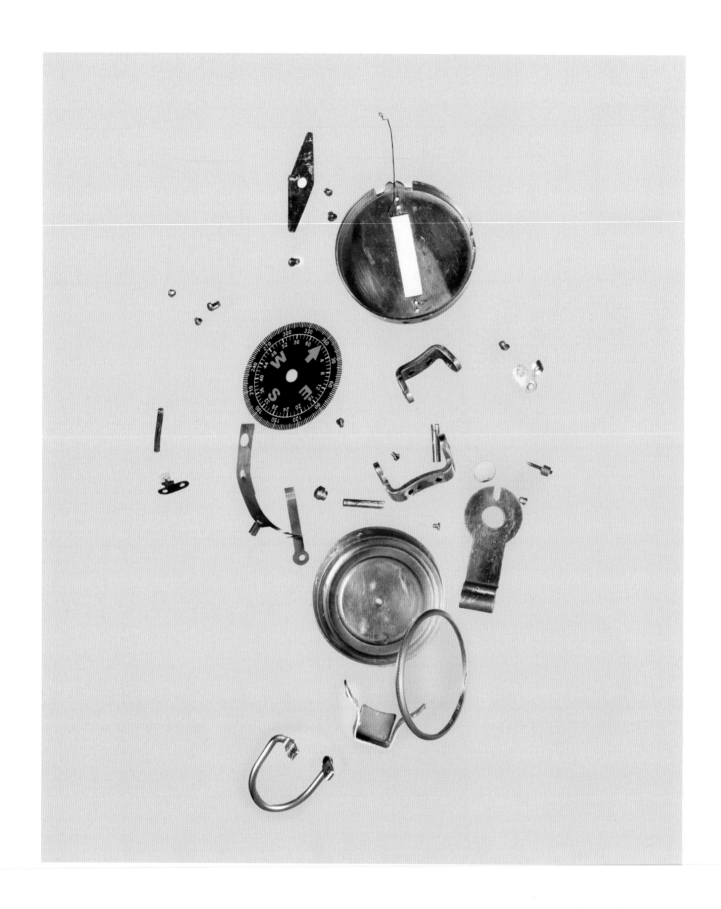

Lensatic Compass, 2000s

Indian Nautical Instruments
Component count: 33

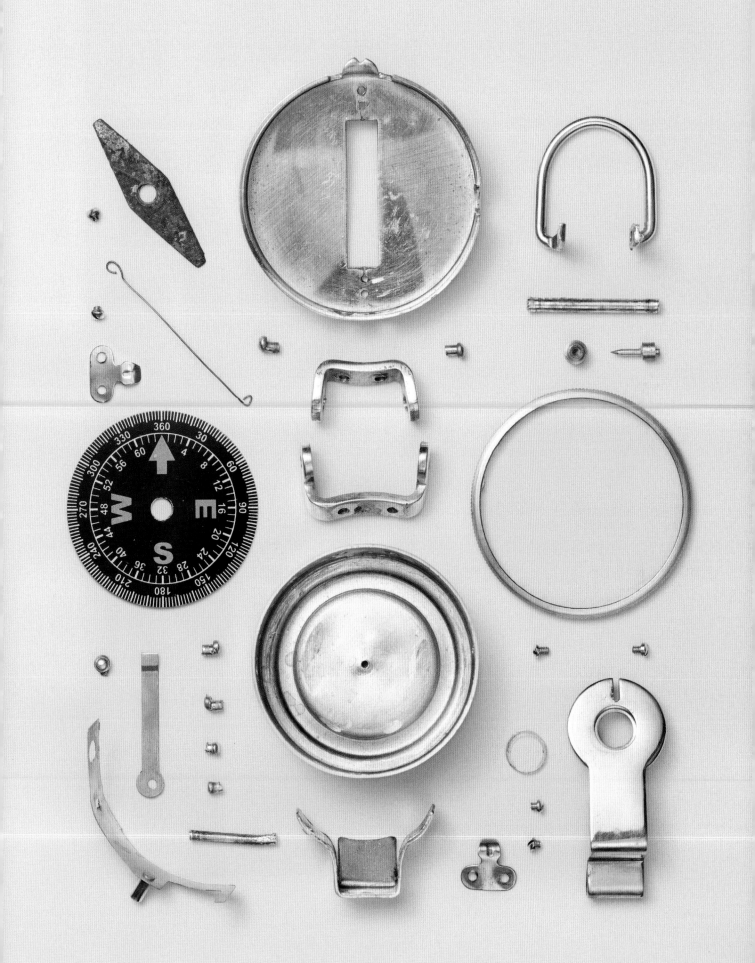

Handheld GPS Unit, 2002

Magellan
Component count: 42

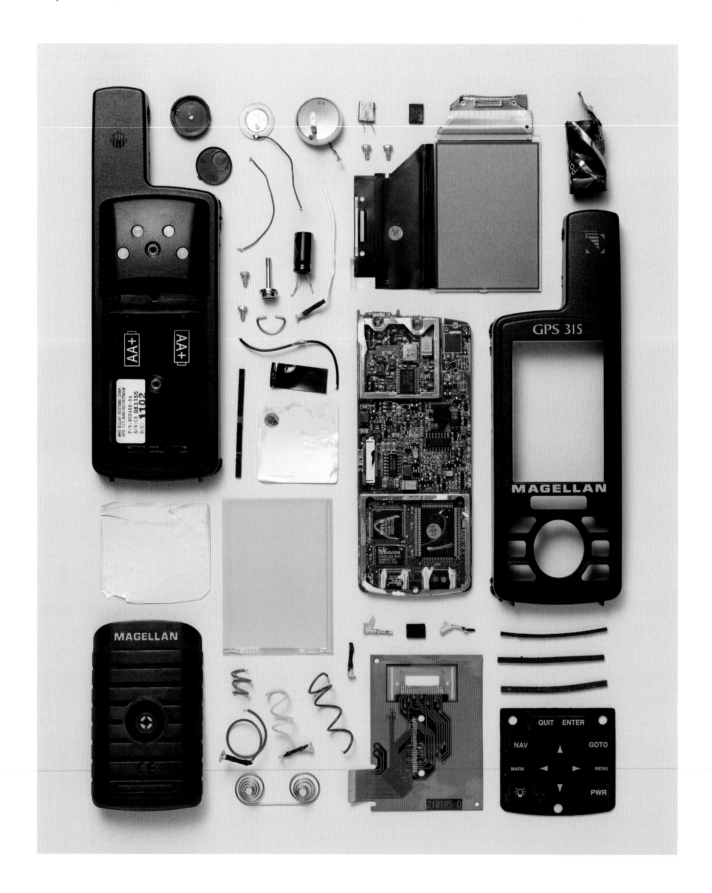

Echo, 2014

Amazon
Component count: 50

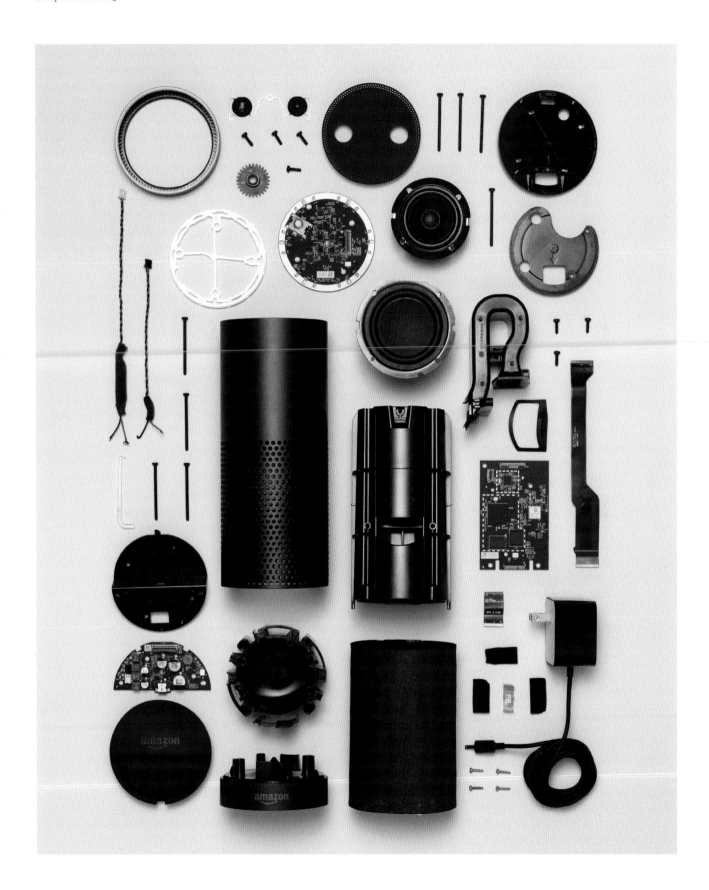

Flashlight, 2002

Maglite
Component count: 37

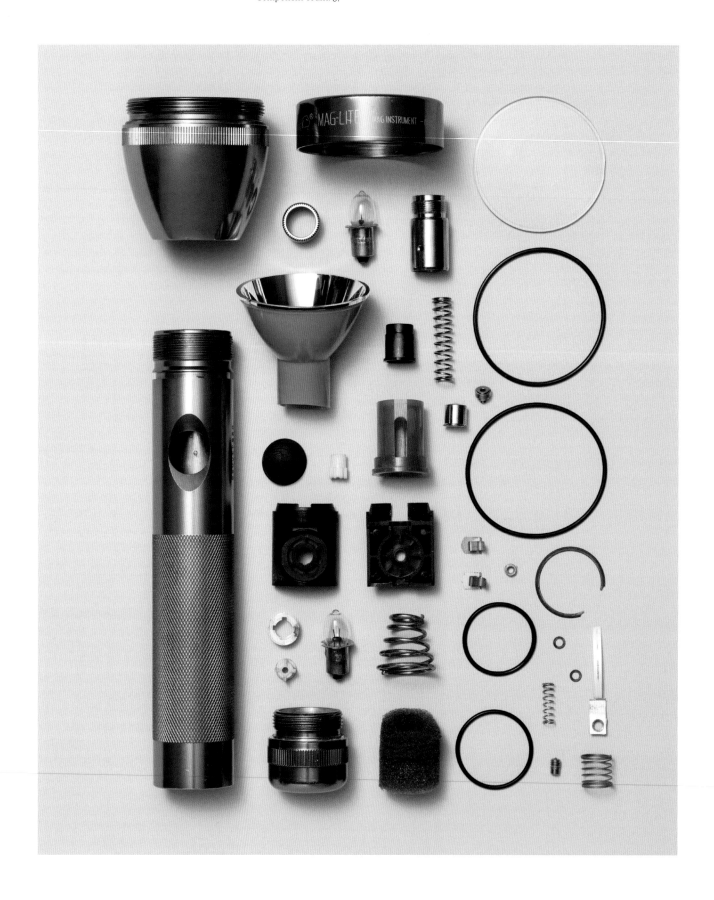

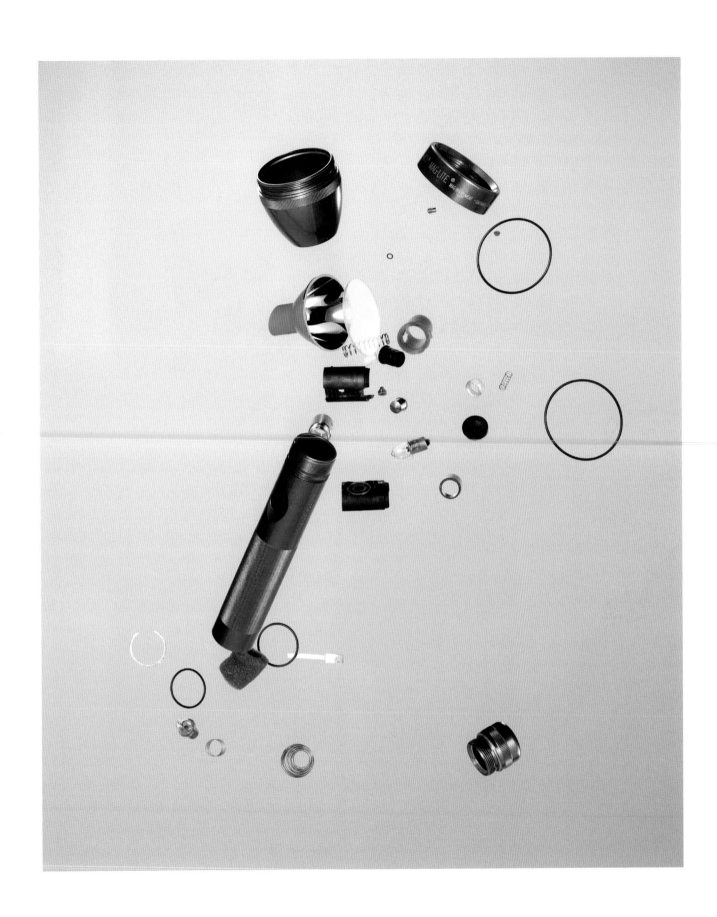

Smartphone, 2007

BlackBerry
Component count: 120

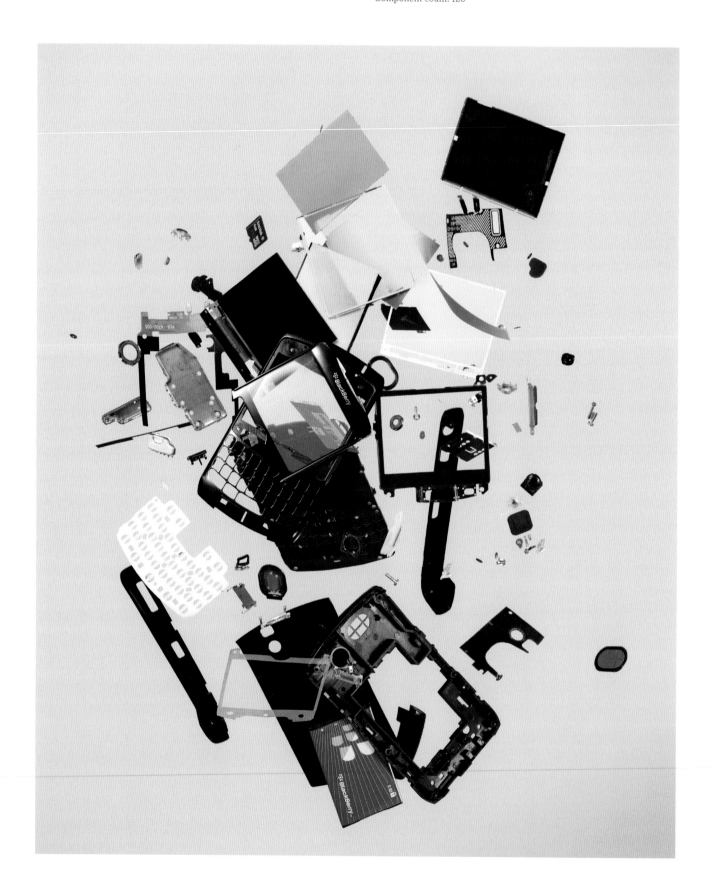

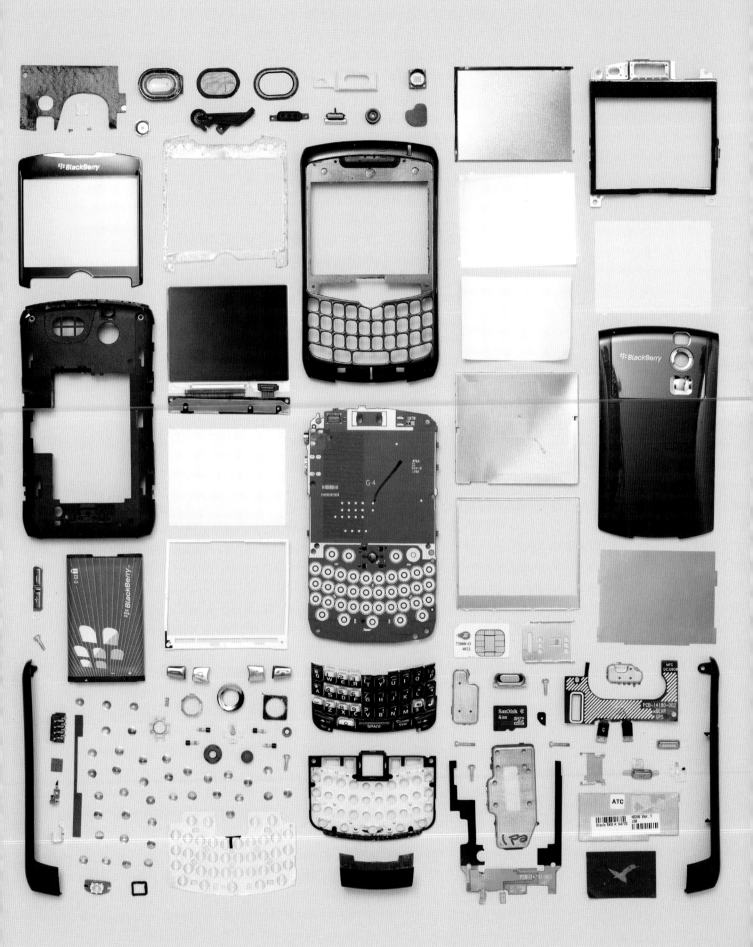

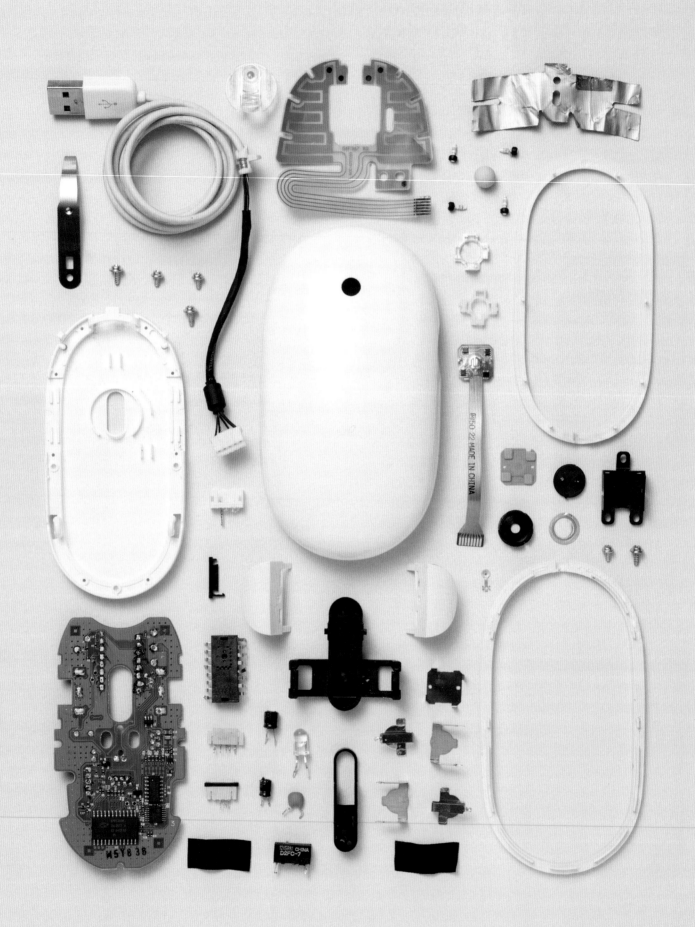

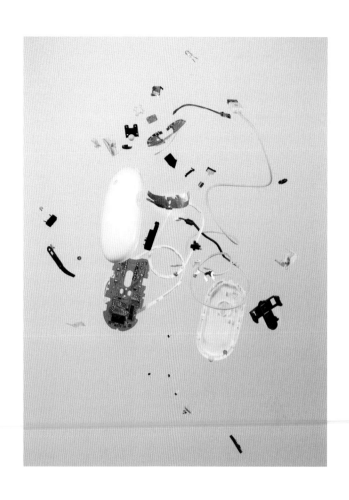

Computer Mouse, 2006

Apple
Component count: 50

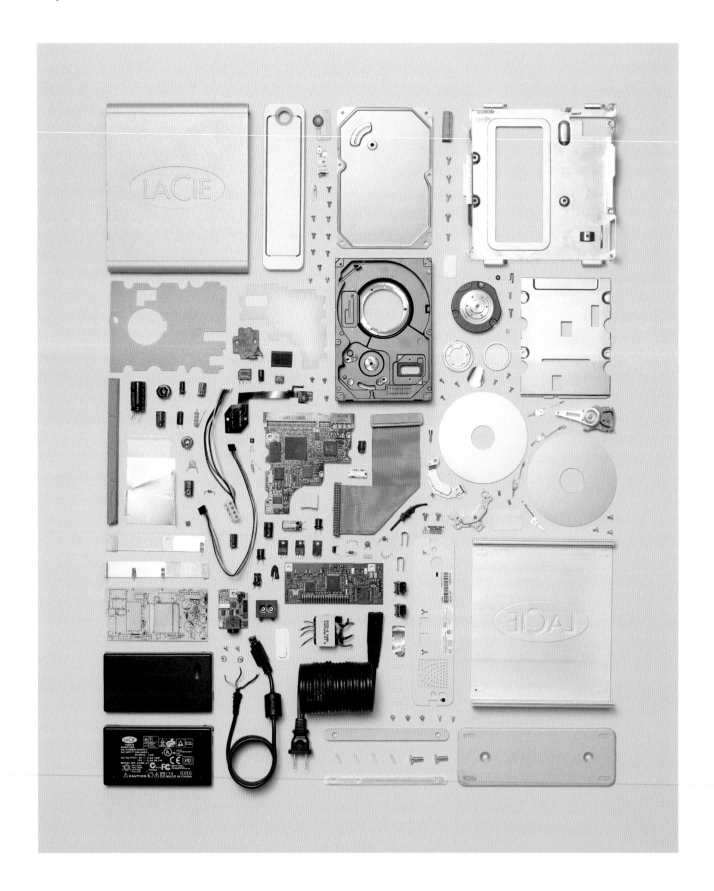

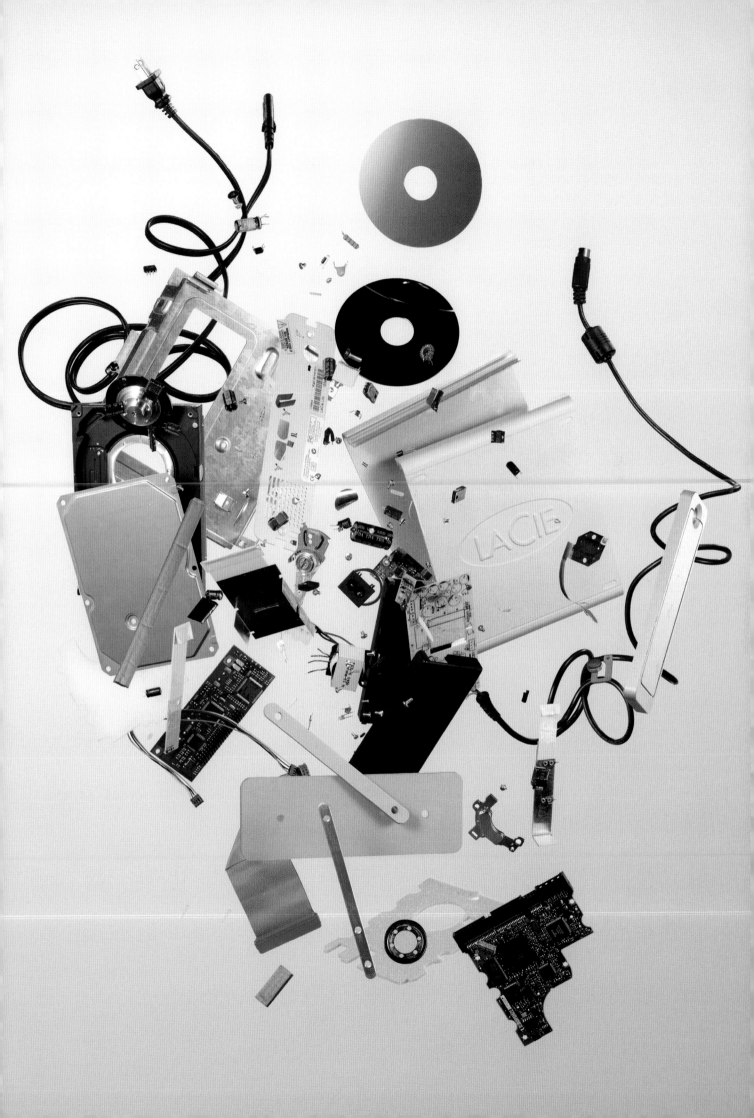

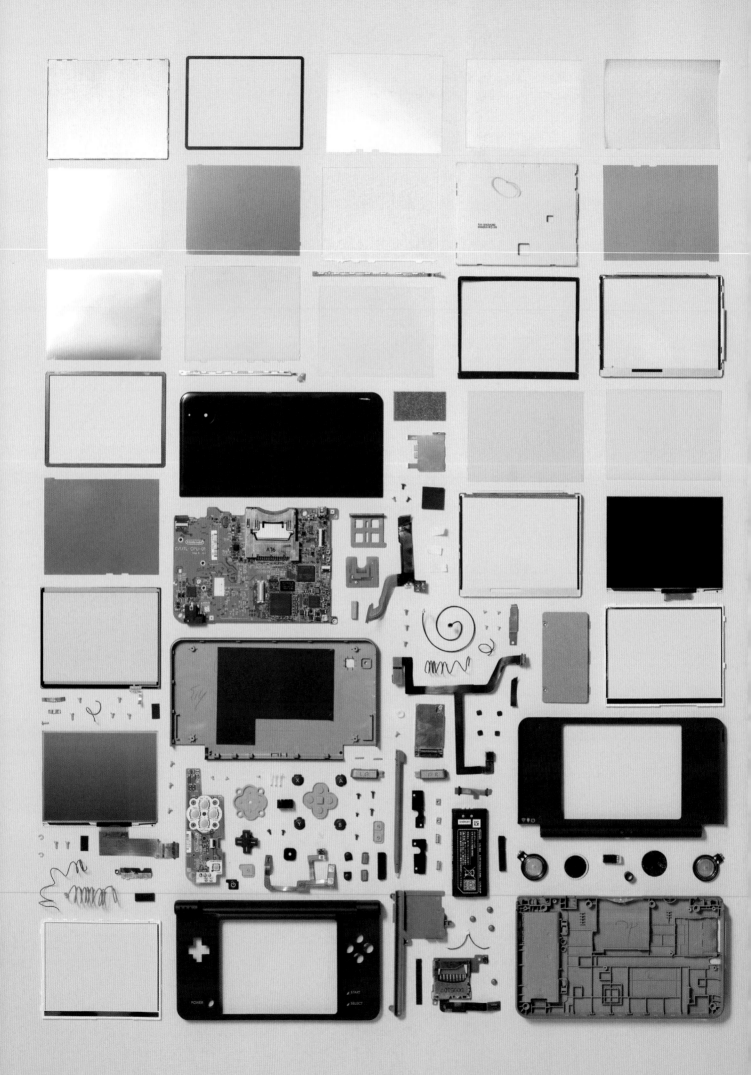

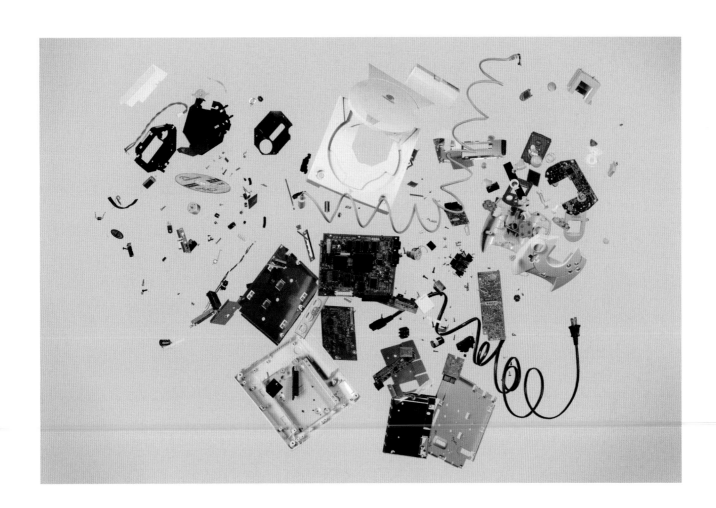

above:
Games Console, 1999

Sega
Component count: 326

opposite
Handheld Games Gonsole, 2010

Nintendo
Component count: 206

overleaf:
iPod 2, 2002

Apple
Component count: 80

Walkman, 1982

Sony
Component count: 370

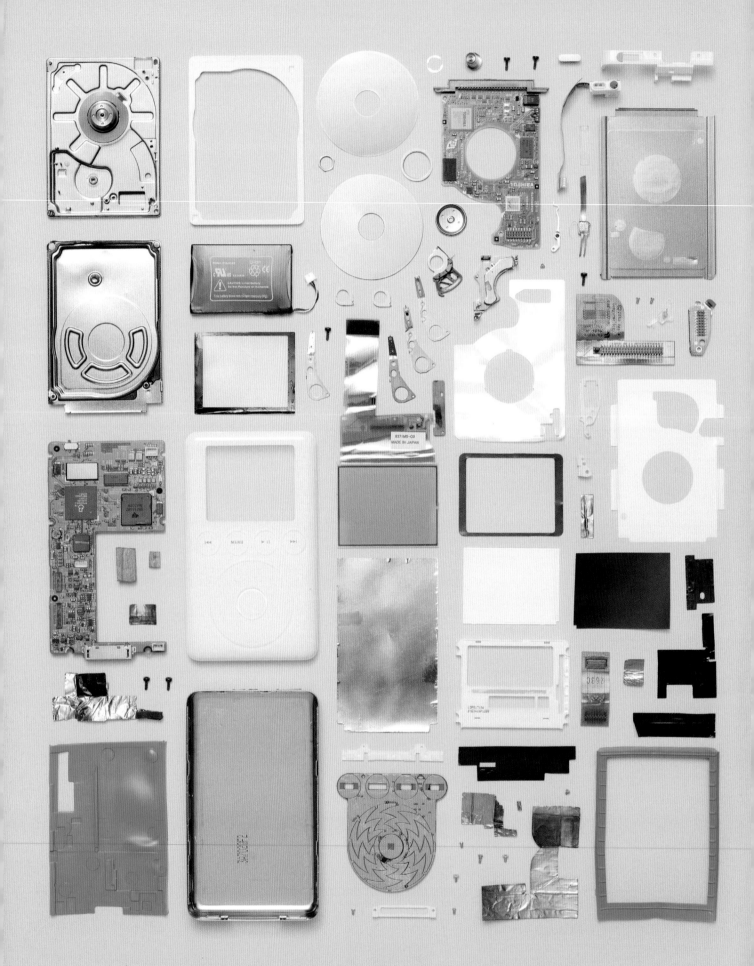

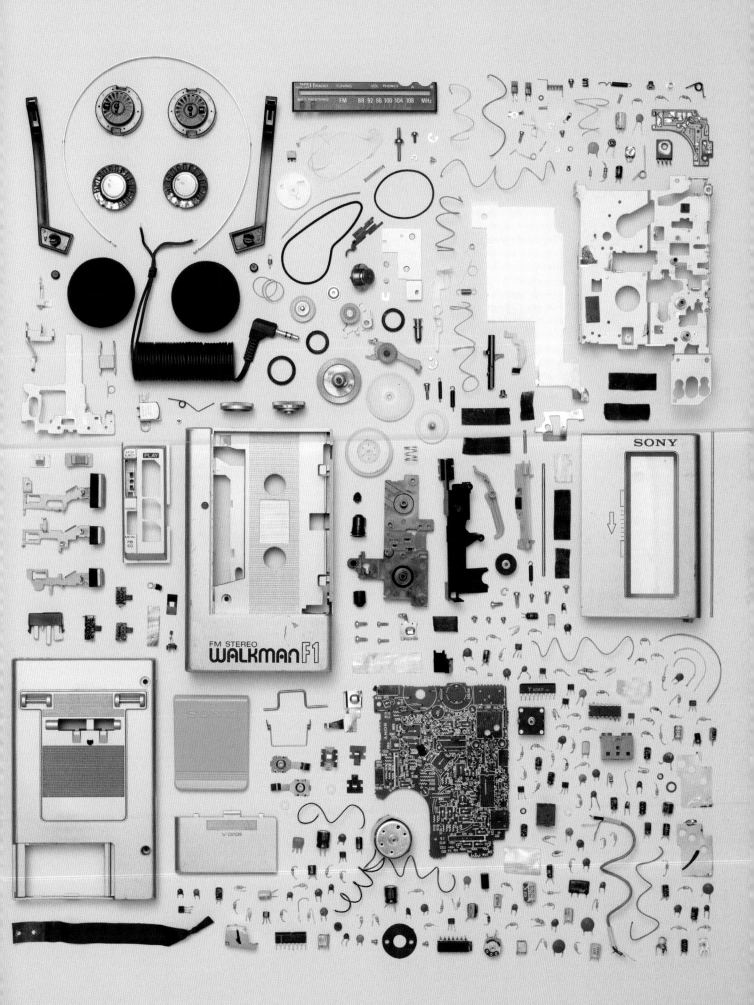

Hair Straighteners, 1989

CHI
Component count: 91

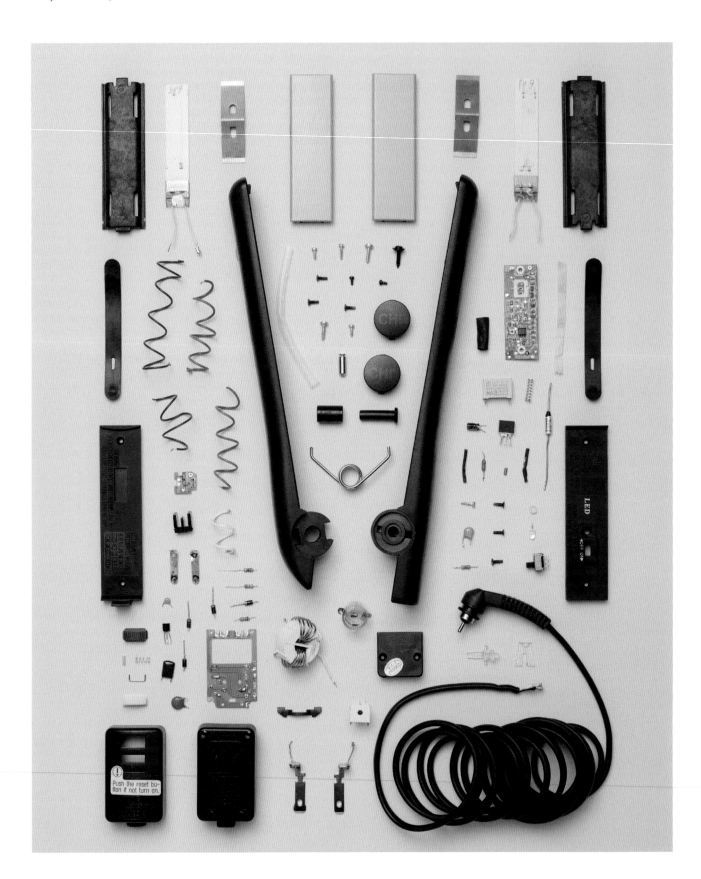

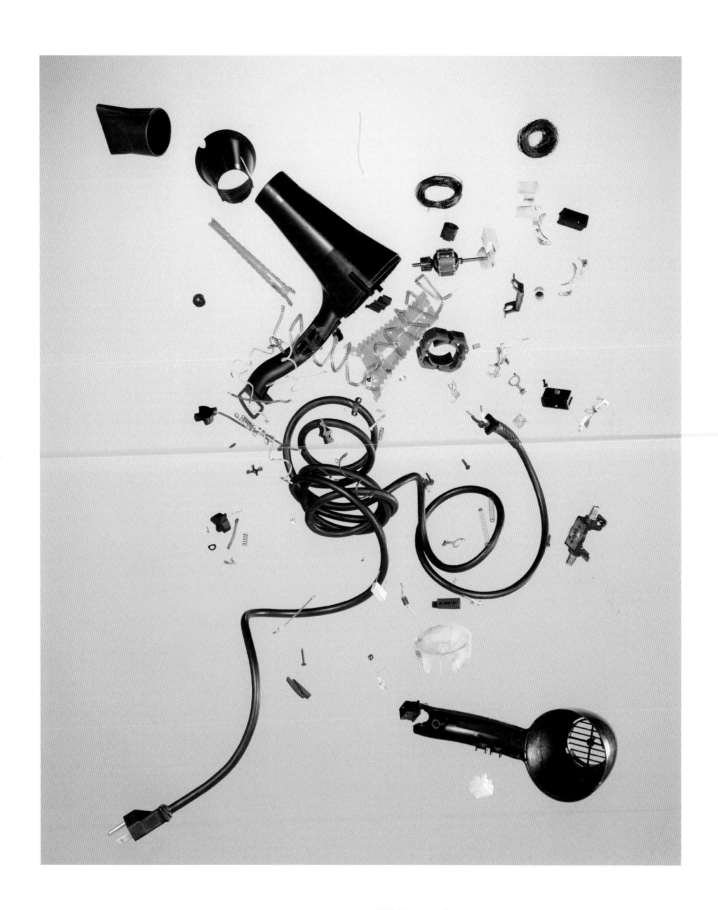

Hair Dryer, 2006

Parlux
Component count: 94

iPad 2, 2011

Apple
Component count: 174

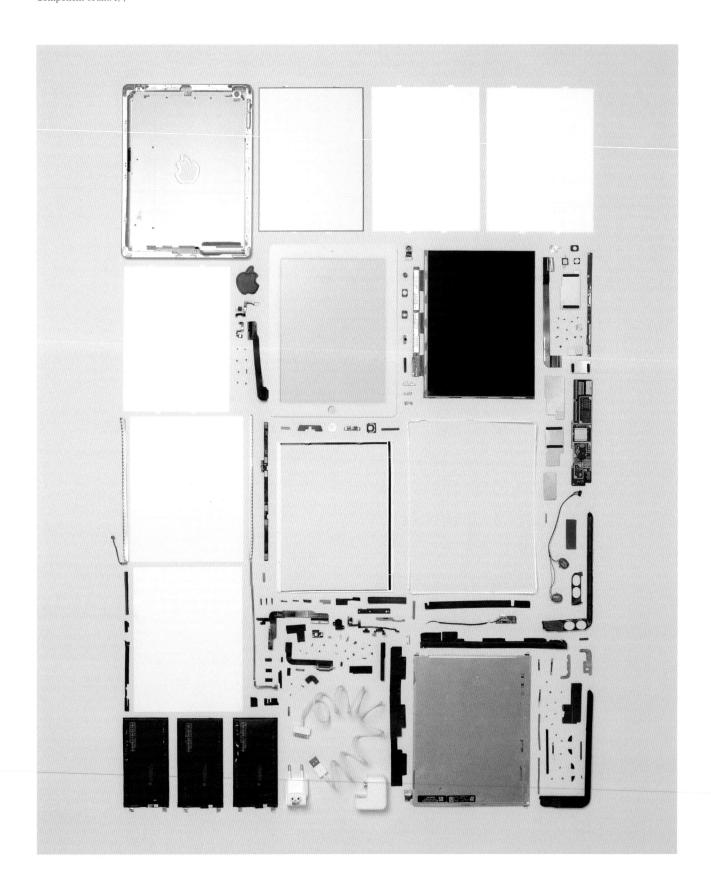

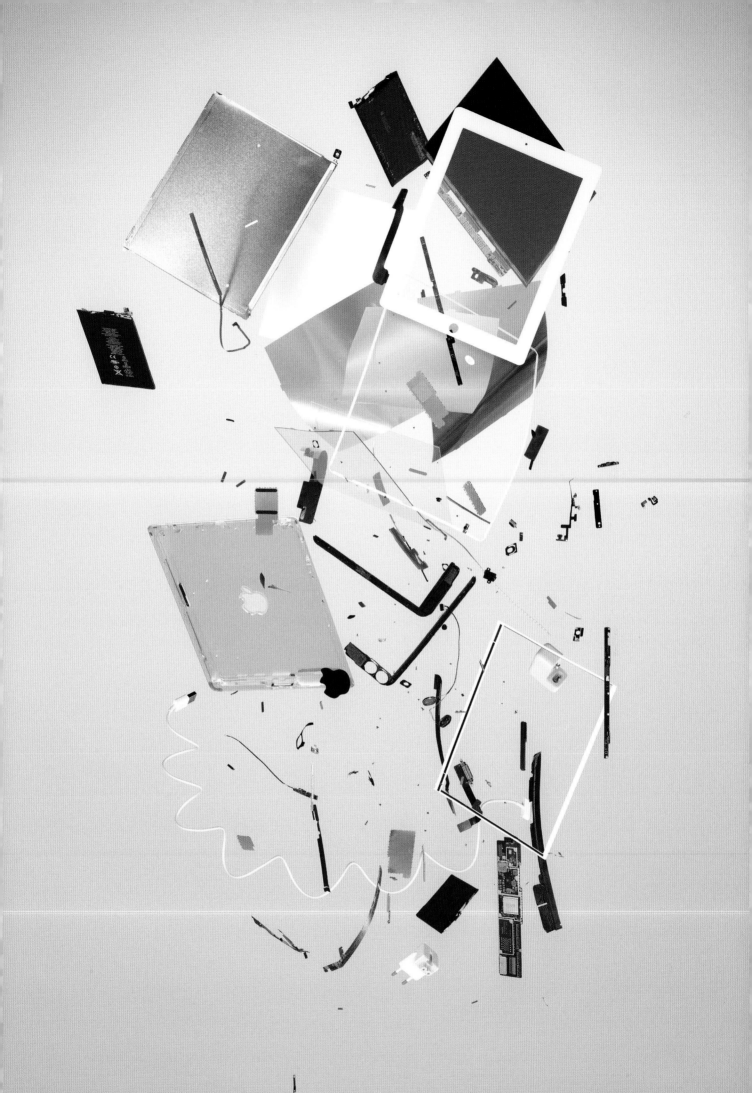

Kyle Wiens is the co-founder and CEO of iFixit, a free online repair community renowned for its product teardowns and open-source service manuals.

#1

THE REPAIR REVOLUTION

The things we own are the product of great effort. Creating a thing requires the gathering together of a team of experts from many disciplines. Over a period of years, they design the product, select materials, engineer innumerable solutions, assemble a global supply chain, and create manufacturing plants. Finally, when the design is complete and the constituent parts are gathered together, the product is assembled. Electronics, in particular, are put together by an army of young, mostly female, Asian factory workers, whose nimble fingers fly as they insert screws, route cables, and snap parts together. Fingers dance to a quiet song with a rhythmic, repetitive beat. The product grows incrementally, piece after piece. Deliberately, methodically, many people in many different places make sure that the product comes together.

The undoing of this work is known as a 'teardown'. The first teardown I remember seeing was in Japan. The artist responsible referred to himself as Kodawarisan, or 'The Fanatic'. A doctor working with the Red Cross, Mitsunobu Tanaka had an uncanny knack for obtaining Apple products early, taking them apart, and showing the rest of us what made them tick. His hobby was applying the same precision he used in his medical practice to reversing the manufacturing processes of products. When I visited his house, he had carefully placed the internal parts of computers on display. Separated from its plastic housing, a PowerBook logic board became an intricate piece of artwork, resembling a living, breathing city viewed from an aircraft flying high above.

Although I could not read the Japanese text that Kodawarisan had produced to accompany his teardowns, his photographs told their own stunning story. The component parts of brand-new gadgets were showcased against a white background. Kodawarisan was able to represent cumulative decades of engineering effort in a single photo. Complex electronics appeared simple and impossibly clean. And like a pebble tossed into a still pond, his photographs of teardowns sent waves through the internet. 'Look, here it is,' they exclaimed. 'The new, opened and bared for all to see.'

Since those days I have since stripped hundreds of devices to their naked logic boards – my organization, iFixit, has built a reputation, in part, on its teardowns of new devices. Yet I did not originally pick up a screwdriver with the intention of sharing the magic inside. Rather, I started to disassemble gadgets for the most pragmatic of reasons. They were broken, I needed them to work, so I fixed them. There was no great flash of insight, no stroke of genius that

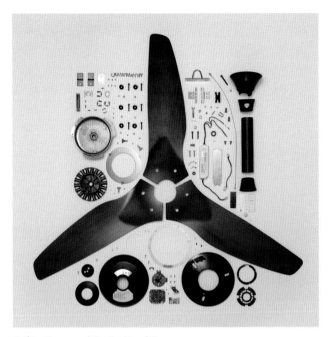

Ceiling Fan, 2014 | Big Ass Fans | Component count: 149

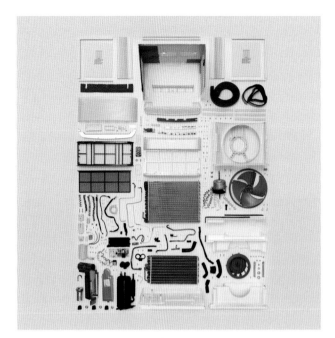

Air Conditioning Unit, 2016 | Frigidaire | Component count: 237

started me on this road. Beginning to produce teardowns was an unexpected consequence of my quest to restore order, to restart things that would not start, and to make broken or failed hardware whole again.

Our real battle is with entropy, the universe's way of inexorably disassembling everything...

Life has always presented a series of problems for us to solve. The way we live today in the developed world depends on a series of solutions found long ago to the most basic human problems: we have road systems to get us from place to place, electricity and oil wells to supply our heating, piping to bring us water and carry away sewage, grocery stores for when we are hungry and hospitals for when we are ill. Now, with most of our material needs taken care of by established infrastructure, we no longer need to invent and make things to guarantee our survival. Instead, we must maintain the advantages we have, and the things we have already made. Our real battle is with entropy, the

universe's way of inexorably disassembling everything that we have made, atom by atom.

Too often, we do not fight back. We throw things away when they break, squandering the years of work and thought and mining and manufacturing that went into them. But this behaviour carries a penalty; if we throw our hands in the air and submit to entropy, we stagnate. We forget that it is solving problems that makes us human and points the way to our collective future.

In his novel, *The Time Machine*, H. G. Wells depicts a future in which humanity has forked into two species: the Morlocks, troglodyte engineers who understand machines and can build and maintain them, and the childlike Eloi, who have perfected the art of lethargy, passing their days in decadence and nights sleeping in buildings that are slowly decaying around them. The book was published in 1895, at a time when steam engines were powering industry and Karl Benz's internal combustion engine was set to change transportation forever, and it describes a seismic societal shift that Wells was one of only a few to foresee. At the end of the nineteenth century, the common citizen had no more clue as to how a steam engine functioned than most of us have about how our mobile phones work today.

Intuitively designed products do not require much, if any, thought to operate. They just work. The easy, natural choice is to use things until they stop working, then toss them aside and rely on someone else to design

Once you grok your possessions, a world of possibilities opens up. Knowing how a thing works enables you to adapt it...

a replacement. To the unquestioning and indifferent among us, advancing technology inevitably becomes more and more like magic. Put clothes into the washing machine, add soap, rinse, repeat. But who will design and maintain our world full of amazing things? What happens when the clothes stop getting clean? We must resist the urge to lapse into Eloic laziness, with its assumption that others will always step in and save us from the consequences of our own lack of curiosity. Fighting back against entropy is not the automatic or even the easy choice. To do so requires a new approach or aspiration in life: to 'grok', or truly understand, the machine.

Once you grok your possessions, a world of possibilities opens up. Knowing how and why a thing works enables you to adapt it to meet your needs. When you have grokked your washing machine, fixing it when it overflows is as simple as cleaning out a clogged drain. Once you know what is gumming up the works, you simply need to get inside and sort it.

Disassembly can be by rote. You remove one screw, and look for the next. In a sense you become a machine yourself, proceeding methodically, allowing yourself to flow through a predefined process to open up another machine. Unscrew, unscrew, remove part. Repeat.

But then you hit a snag. A place where the next step is not obvious. An interruption in the flow. You pause, pick up the thing you are investigating, and look for a new angle. Like an explorer who has reached a dead end in a cave, you

retrace your steps looking for an alternative solution. You know that there is further to go, but in which direction? Broadening your horizon, you look for additional solutions. This is where the creativity begins. You ask yourself, 'If I were designing this, how would I have held it together?' The answer is there in front of you. The challenge is to step back and identify the problem to which it was the solution.

Learning to repair is an incremental, stair-stepped process. Flashes of insight open up great new possibilities, and the more designs you see, the more products you have examined, the better at it you become. The process of disassembling products requires an assimilation of the minds of the creators. If your computer monitor will not turn on, research on the internet reveals that a common cause of that behaviour is a blown capacitor – a diagnosis that sounds like gibberish at first. But then you read further:

The soul of the creator is imbued in the machine, and as users we glean wisdom from understanding its workings.

about why computers have capacitors, and how to locate a capacitor in your machine. And there is a strong empirical element, too. You learn that a bulging top and deposits of dried electrolyte on a capacitor are indications that it has failed. When you work out how to replace the failed capacitor, then power up the monitor and it lights up again, you smile. For a moment, you have thought like the engineer who designed it. You have grokked the machine.

When you next take something apart, you will remember how you pried open the monitor case with guitar picks because there were no screws visible on the outside. You will remember how you had to trace cables to their sources and pull them up straight to detach their fragile connectors. And when you hit a snag again, you will push on, because you will remember the euphoric sense of satisfaction that comes with making something work.

Repair is the process of connecting mind and thing; you are both creator and fixer. With simple tools – screwdrivers, spanners, magnetic sorting trays, pry tools of varying thickness and hardness – fixers pick away at a device's engineering, pulling back the curtain and opening the 'black box'. Sometimes, the product seems to exhibit disdain for the fixer, as if the maker is saying, 'I glued this together because I do not want you to know my creation.' In those circumstances fixers must evolve, finding more powerful tools, such as industrial-strength heat guns and dental picks; they must even craft special screwdrivers to unlock proprietary screws. But at other times a device seems to be carefully designed with the fixer in mind, so that it can be lovingly maintained through the years. Hand-twist knobs and easily opened latches invite you in, indicating a machine that is intended to journey with its owner through a lifetime. With such benevolent products, designed to be disassembled and reassembled, maintenance is as intuitive as their daily use. The best-designed products are robust and intended to last, rather than be dumped prematurely in the landfill. Human and machine should wear in together, gaining experience and texture along the way.

The soul of the creator is imbued in the machine, and as users we glean wisdom from understanding its workings. To disassemble is to learn, to mend, and to move forward. Understanding the things we own allows us to do what we do best: solve problems.

What happens when we do not know how things work? We are cut off, trapped in a modern wasteland where we can only try to solve problems with our credit cards rather than with our hands and brains. Things fail, and in a world that no longer encourages us to seek practical solutions we toss them aside, looking to advertisements to tell us what to buy next. To throw something away is to give up on problem solving, and in so doing we cast aside an important aspect of that which makes us human.

A refrigerator that ceases to operate should be viewed as a challenge, a gauntlet thrown down by entropy. Saying 'I am not willing to solve this problem' is not acceptable because it forsakes our roots and endangers our future.

We all have to fight entropy, and refusing to engage in that battle is to ignore what makes us human.

When we understand the problem and craft a solution, we reclaim mastery over our lives, breaking outside the bubble that manufacturers have cast us into, hoping for repeated sales. Looking closer, you will see that your refrigerator is frosting over because the heating coil has worn out. It functioned for years, but eventually the base material failed. Replacing the broken part will cost far less money and probably no more time than replacing the entire refrigerator – and you will have beaten the problem instead of letting it beat you.

Life without conflict is a fraud. We all have to fight entropy, and refusing to engage in that battle is to ignore what makes us human. Every time you fix something that entropy has broken, you claim a small victory.

Outsourcing repairs and allowing others to fight our battles by proxy is a short-term solution, but again the opportunity to test our own abilities is lost. At stake is our own soul, the problem-solving core of our humanity. Retaking control means taking our stuff apart, seeing what makes it tick, and learning to read the minds of its creators. Often, the solution is as simple as replacing a heating coil. Sometimes, the mend will take a great effort. Regardless, we must keep fixing: for the beauty of a teardown, for the satisfaction of a repair success, and for the sake of the basic human drive to make the world work in a better way.

To live well is to press forward. Seeking out new challenges and opportunities fulfils us and makes us into better people. Every challenge that we overcome grants us greater perspective and prepares us for the next challenge. The solutions we craft become a part of us, making us better as we improve the world around us.

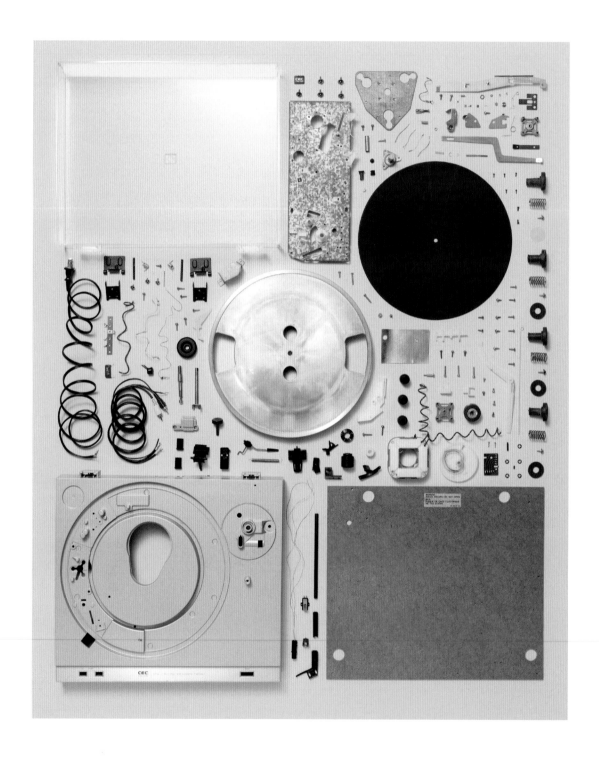

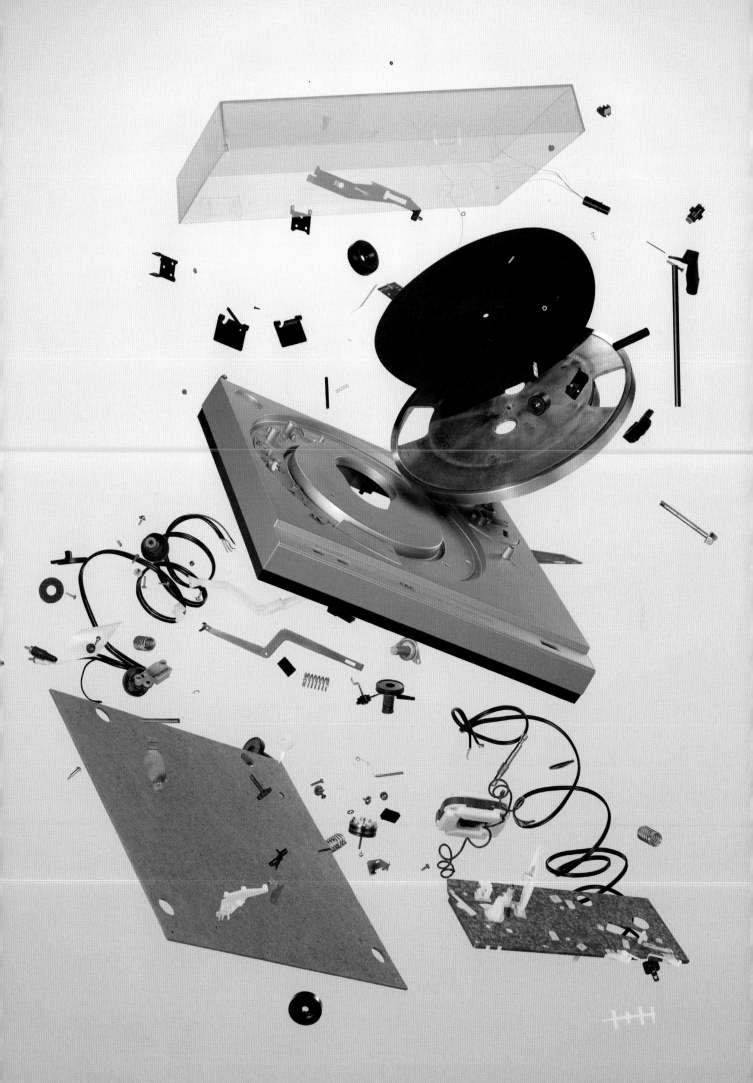

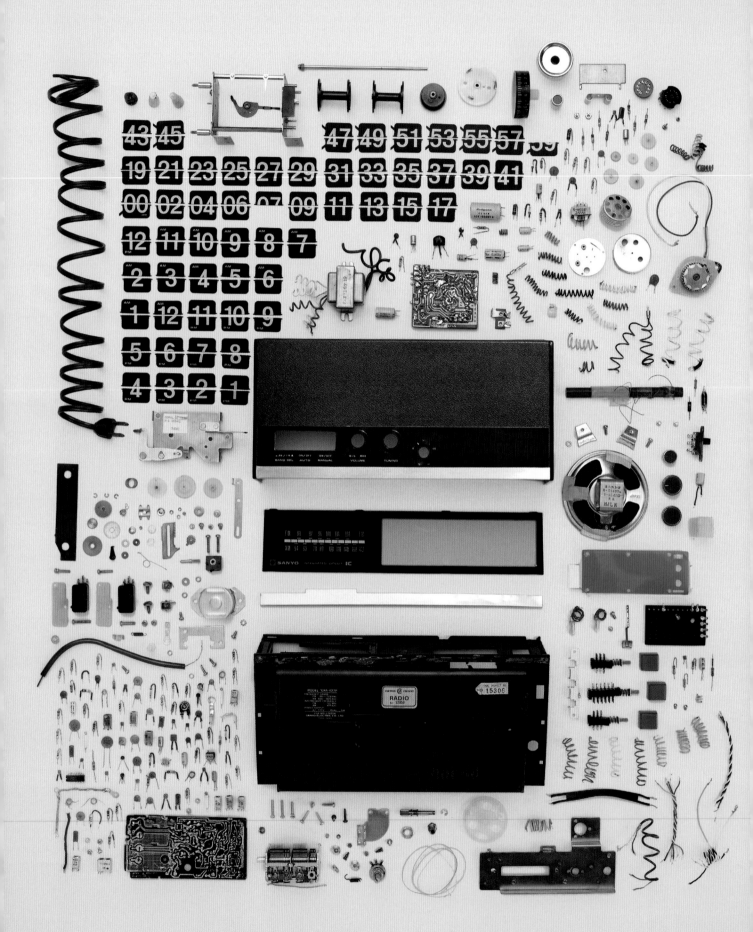

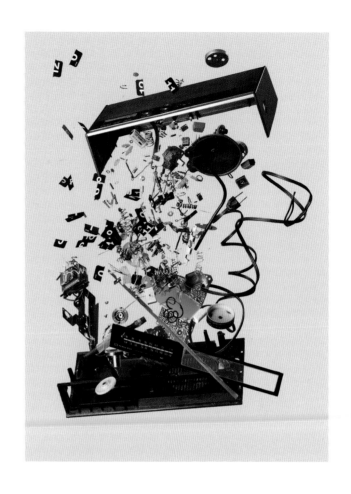

Flip Clock, 1970s

Sanyo
Component count: 426

Rotary Telephone, 1980s

Northern Electric
Component count: 148

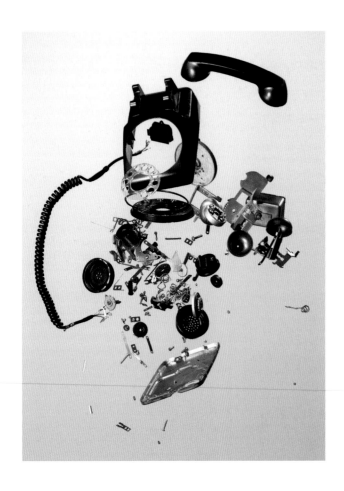

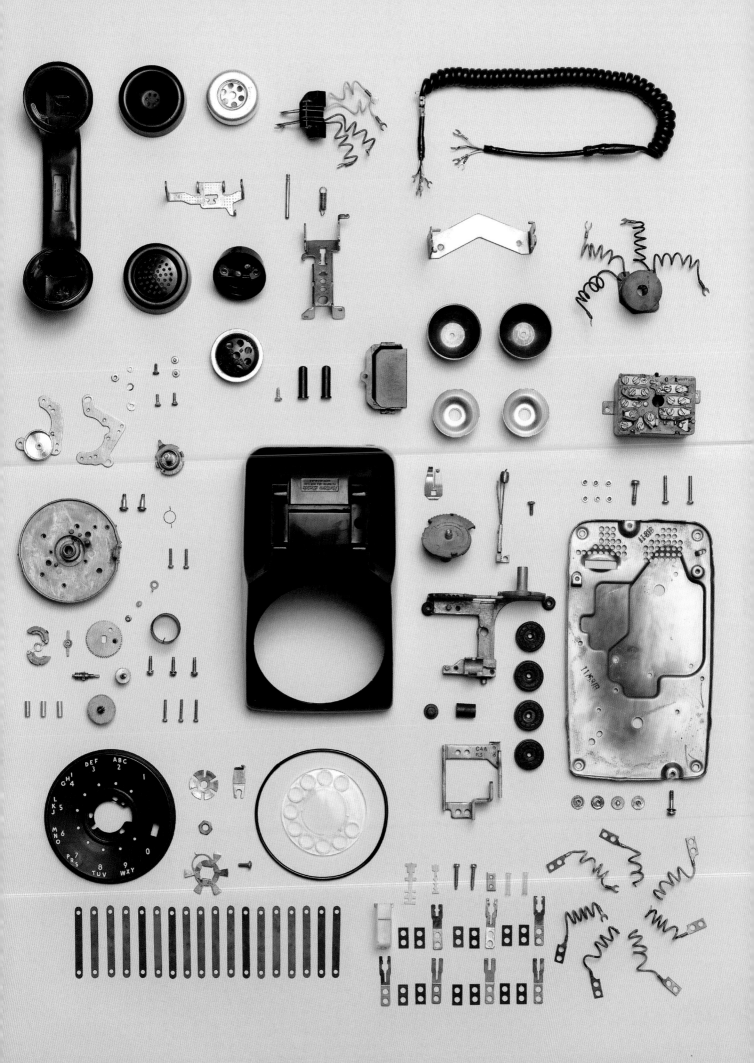

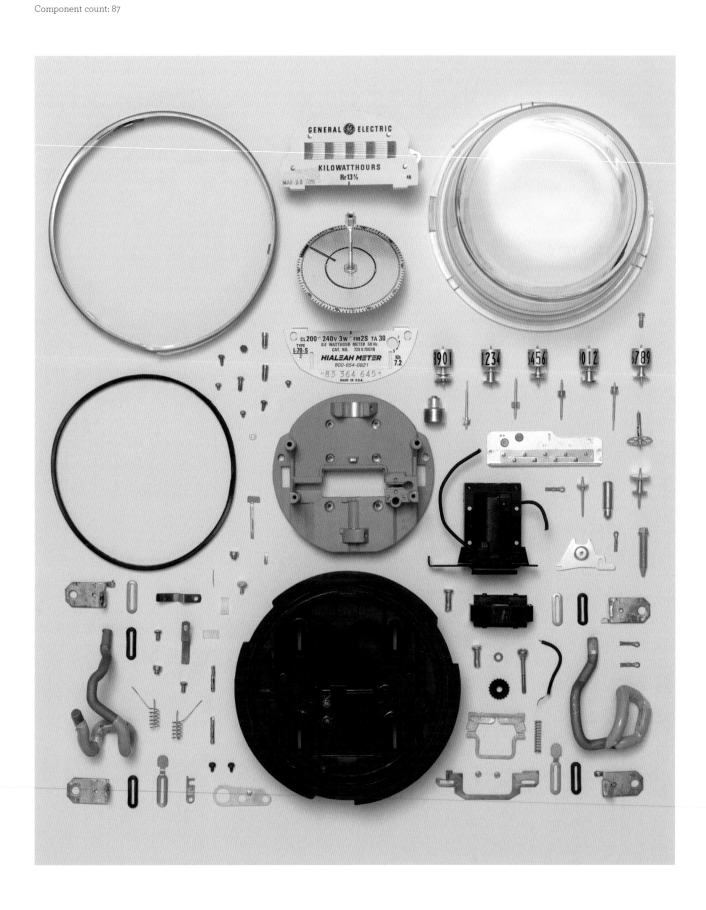

Gas Meter, 2005

Elster American
Component count: 131

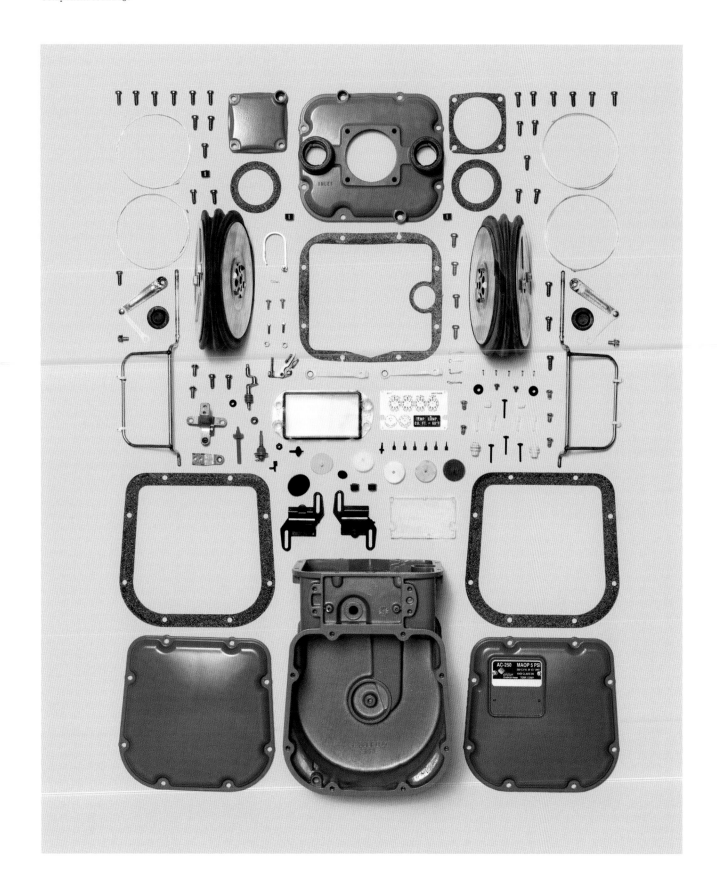

SLR Camera, 1973

Asahi
Component count: 576

overleaf:
Digital SLR Camera, 2012

Sony
Component count: 580

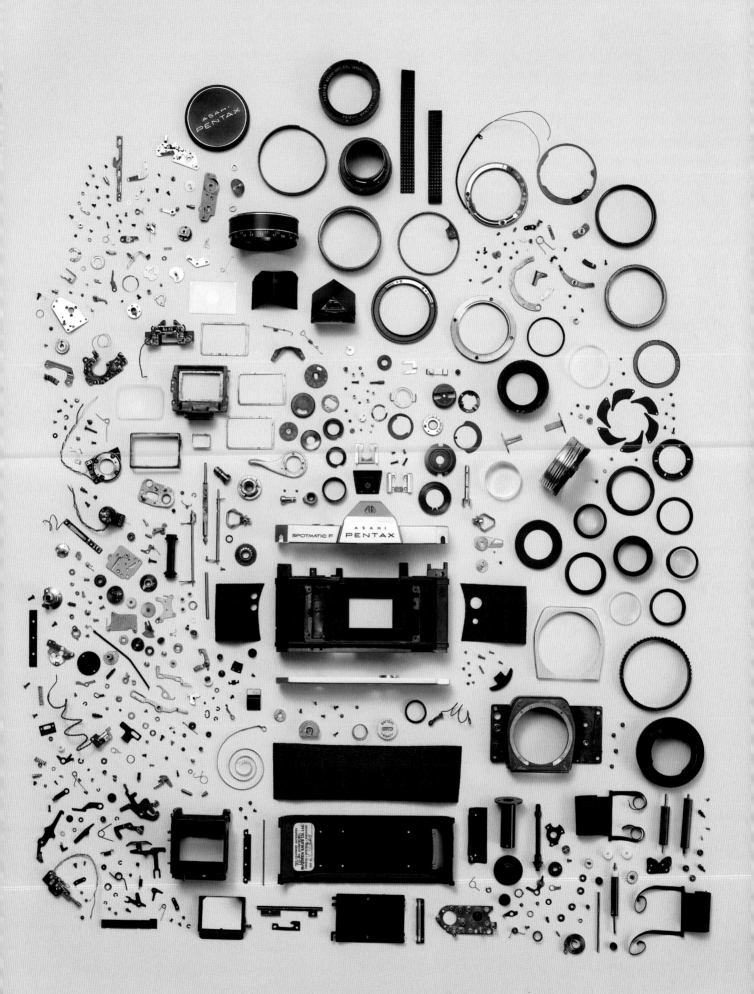

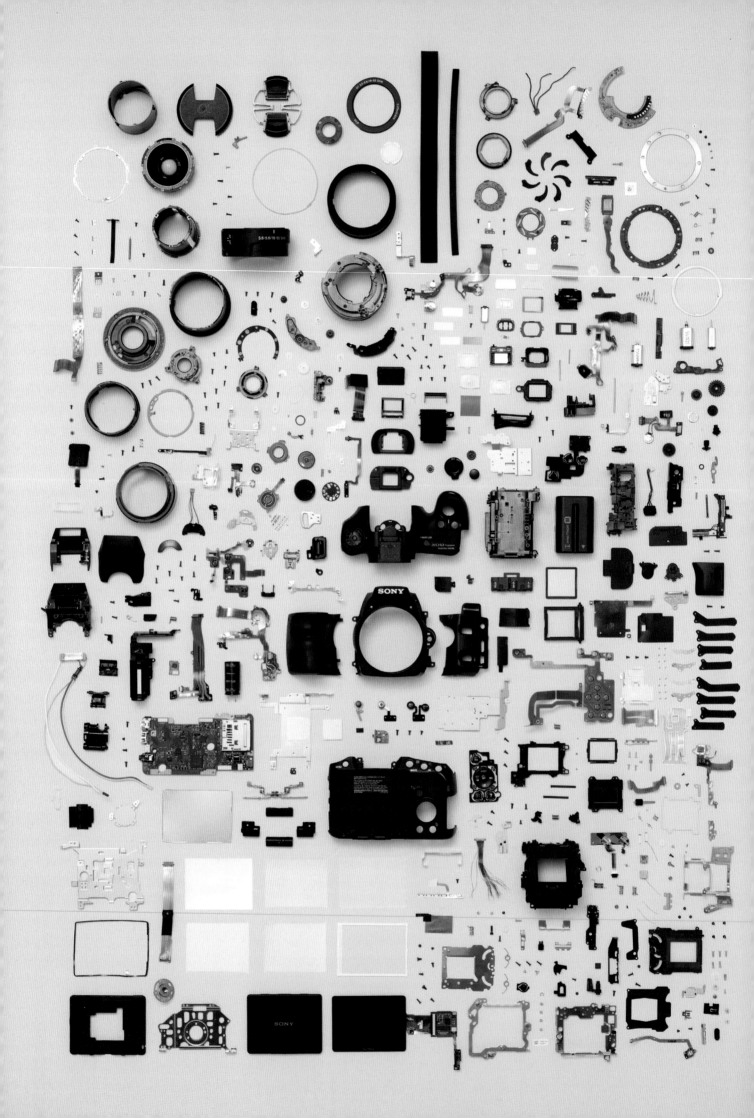

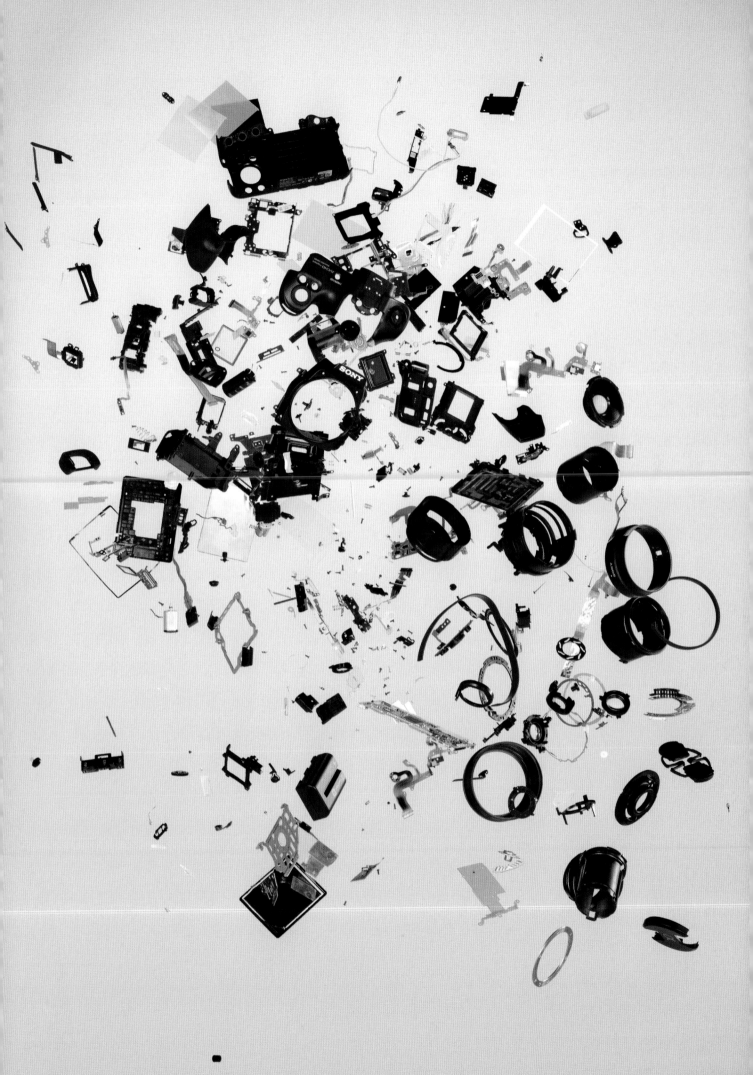

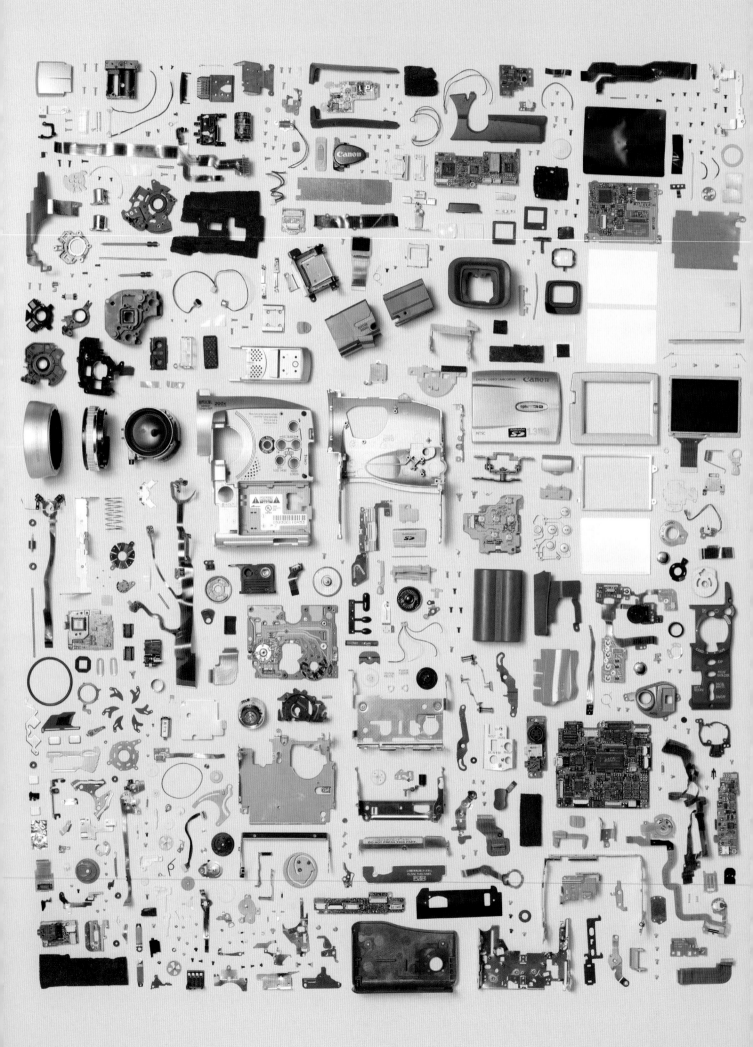

Digital Video Camera, 2005

Canon
Component count: 558

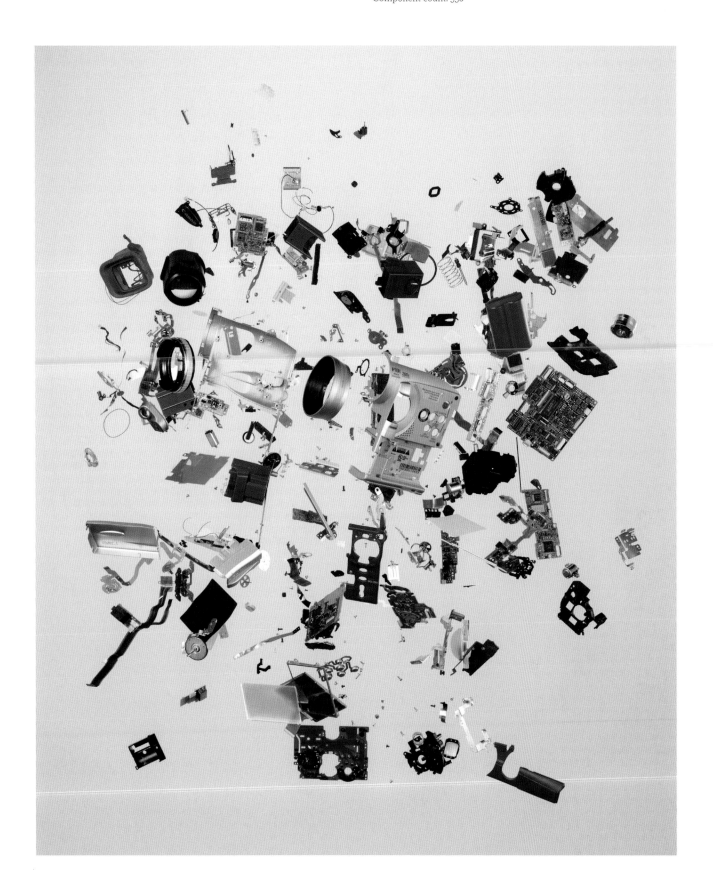

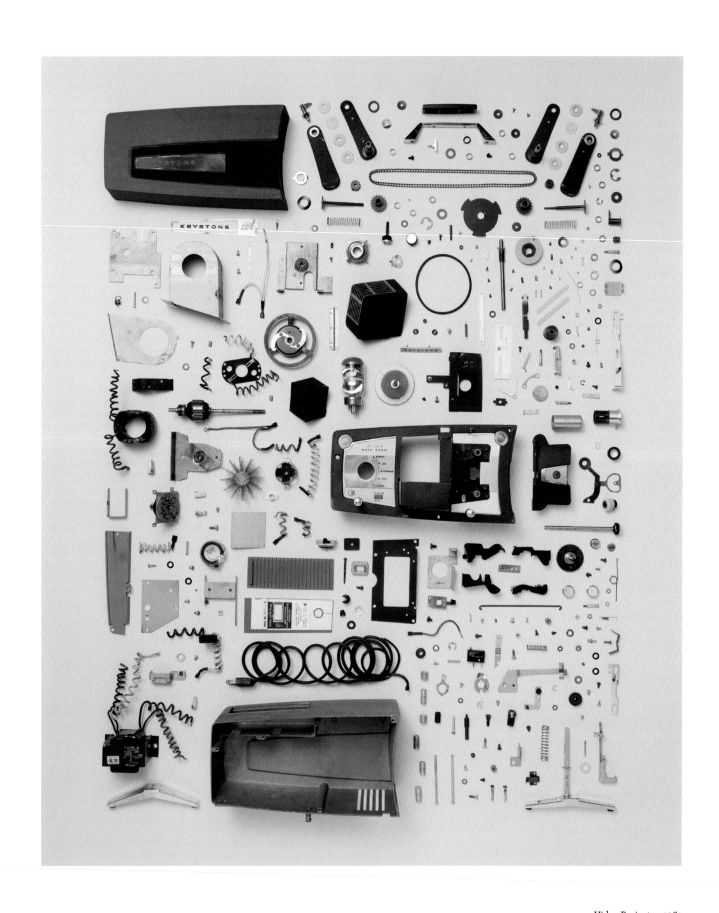

Video Projector, 1961

Keystone
Component count: 355

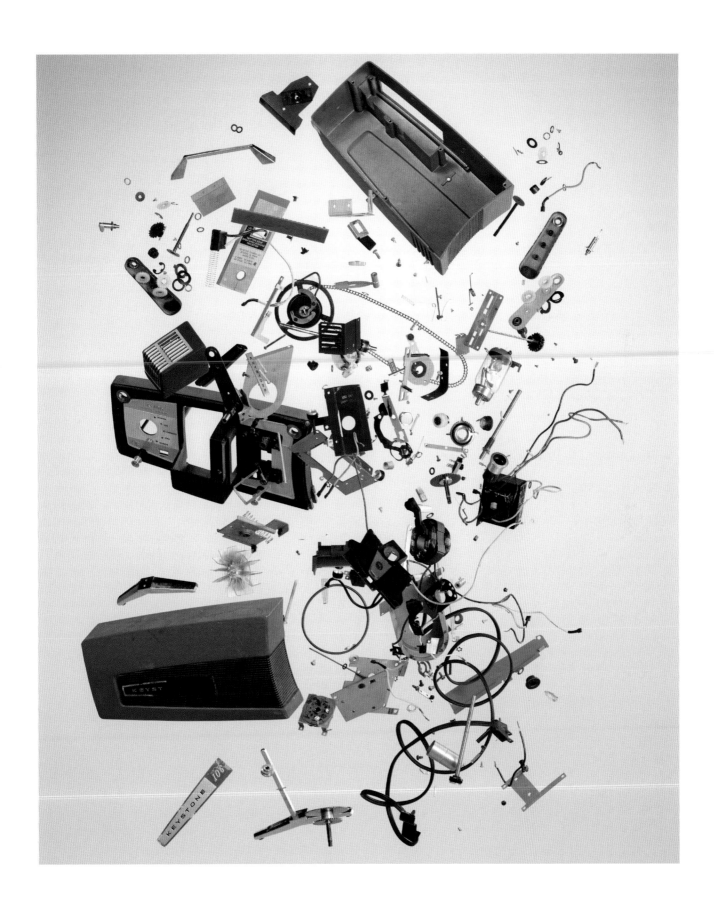

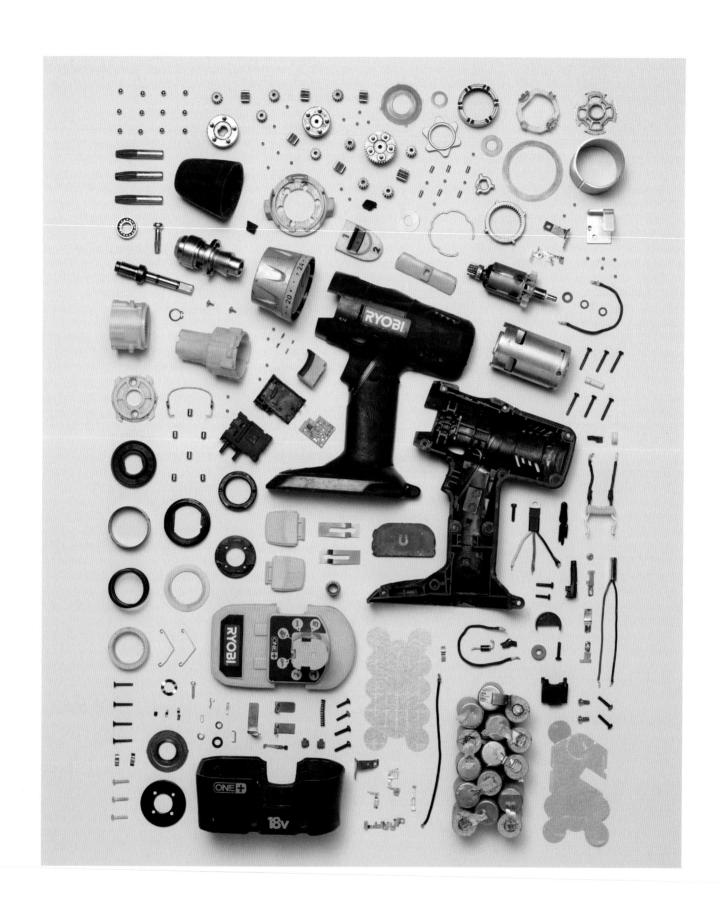

Power Drill, 2006

Ryobi

Component count: 216

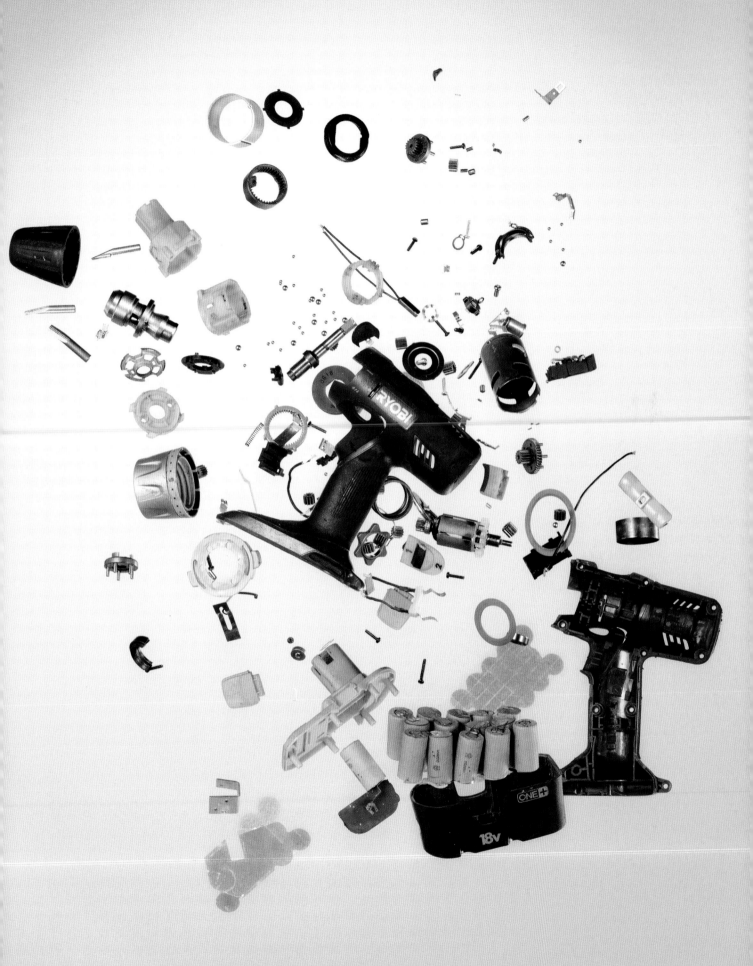

Desk Lamp, 2002

IKEA
Component count: 73

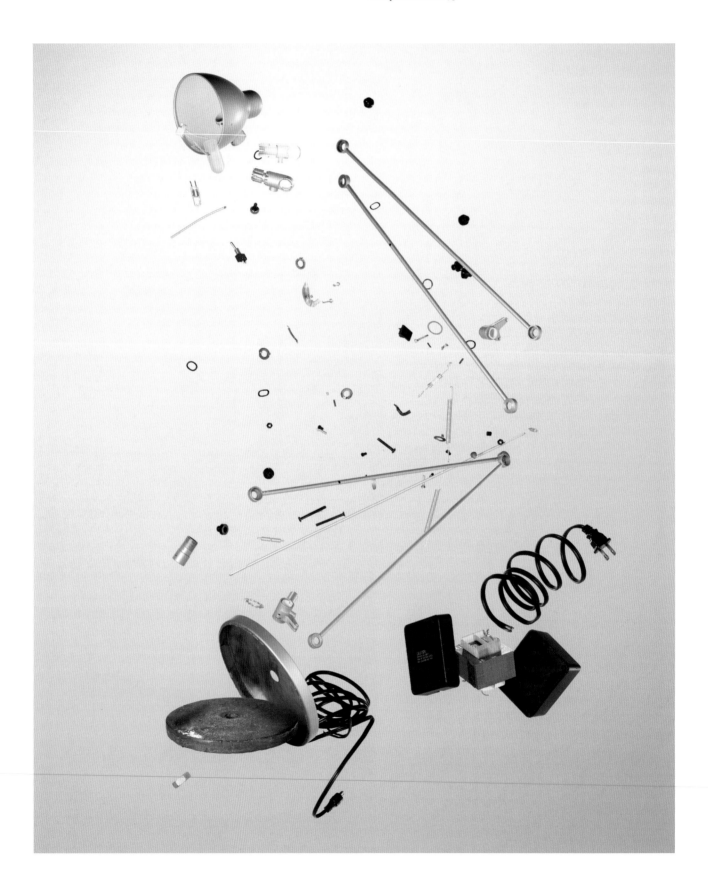

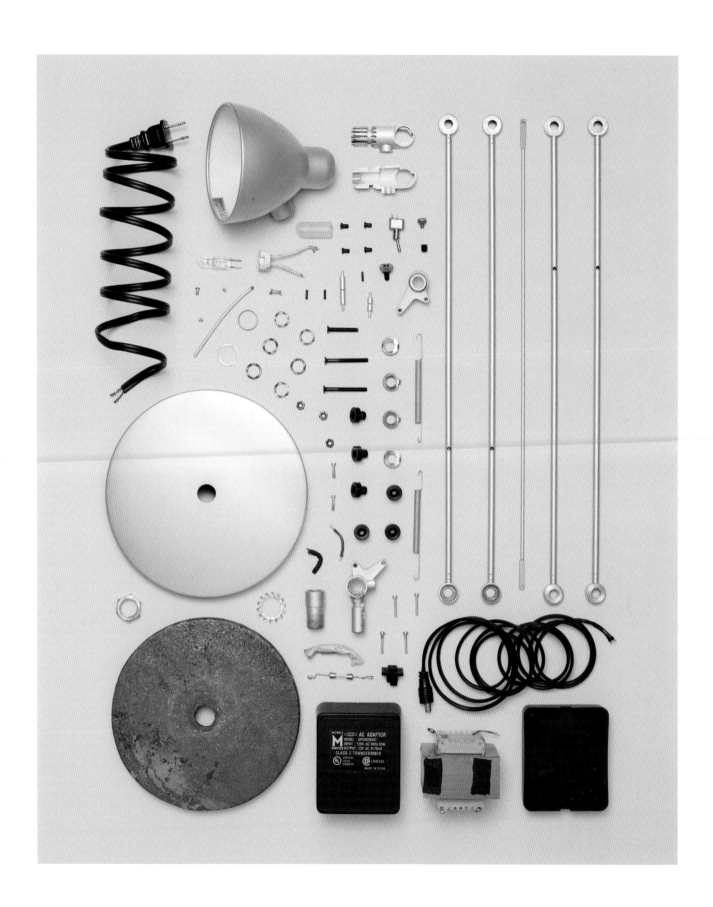

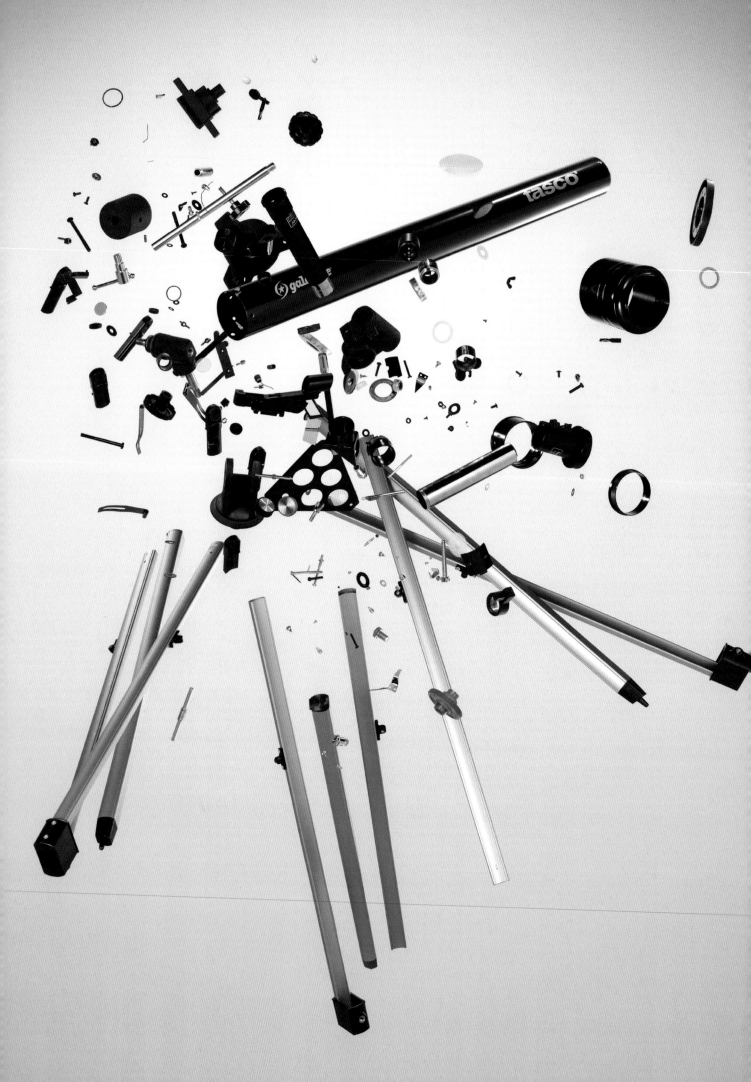

Telescope, 2000

Tasco
Component count: 223

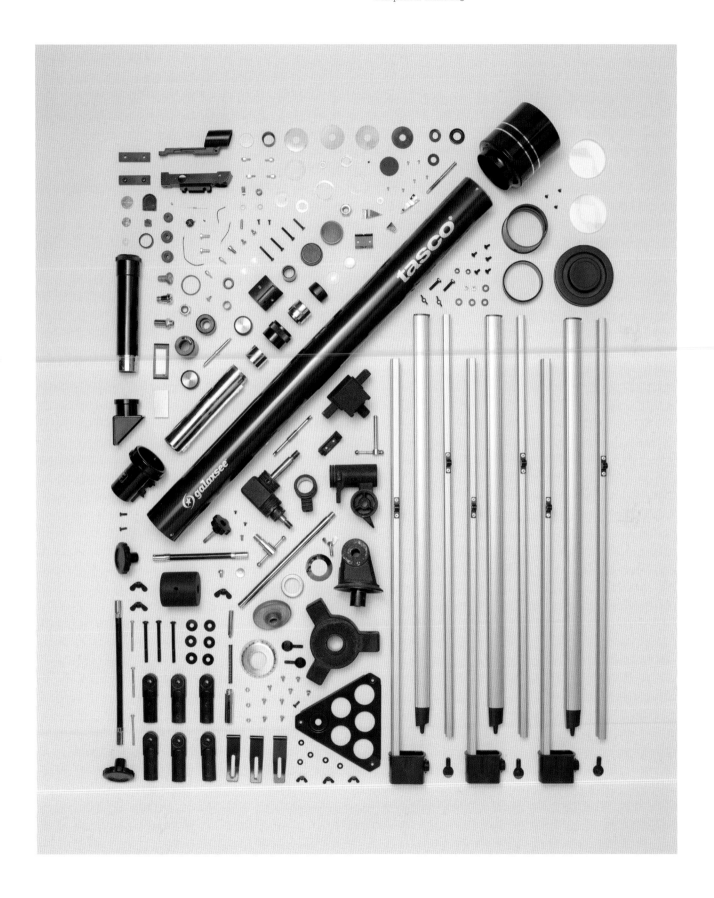

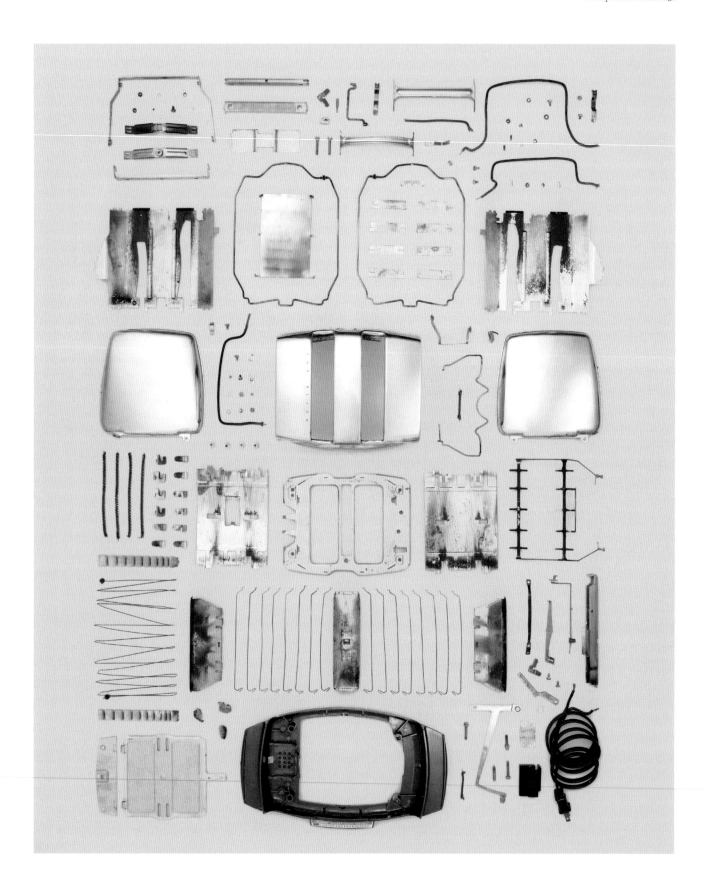

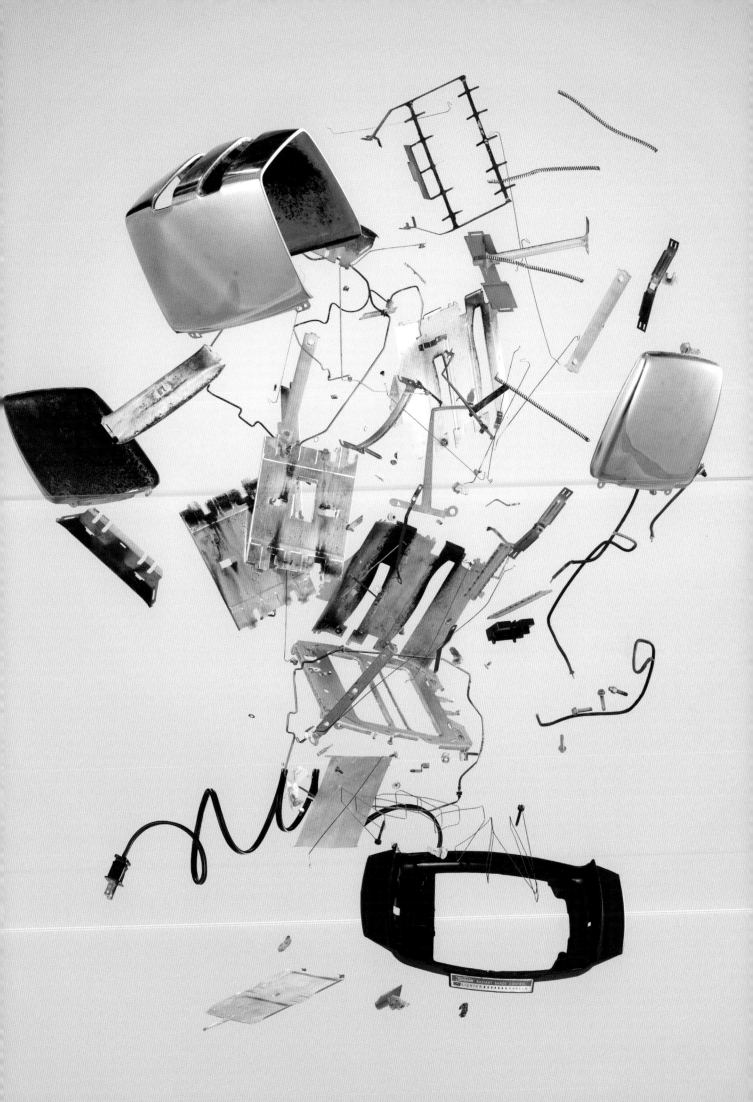

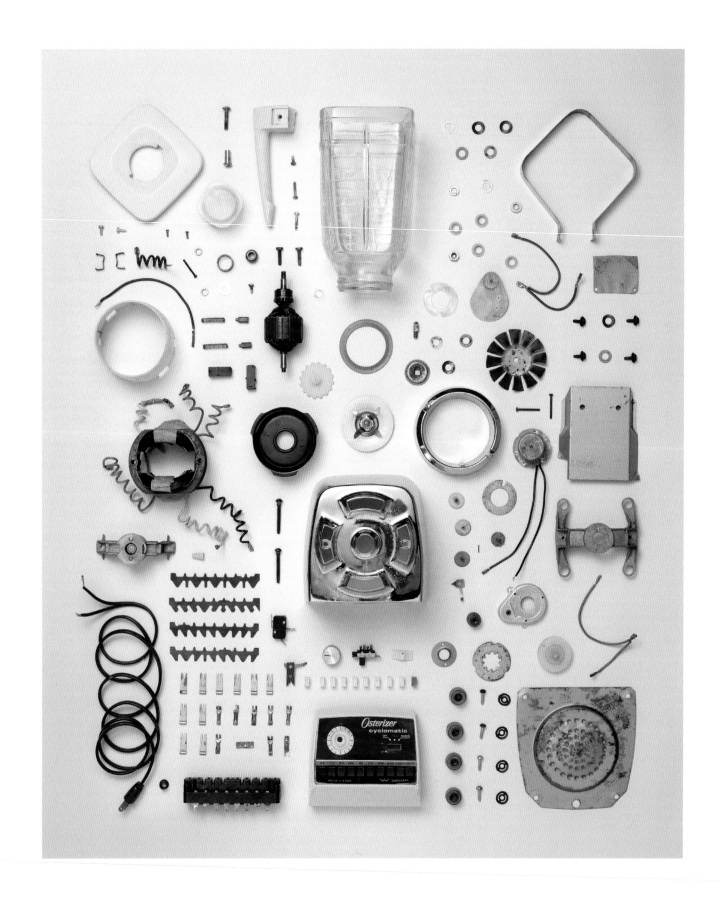

Blender, 1960s

Oster
Component count: 147

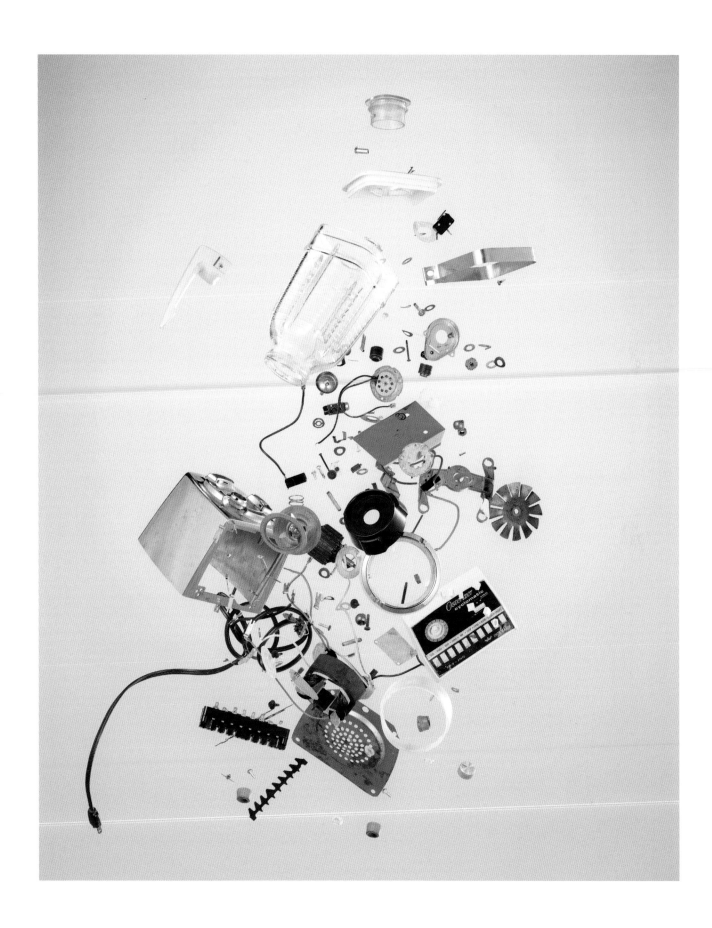

DVD Player, 2005

Toshiba
Component count: 195

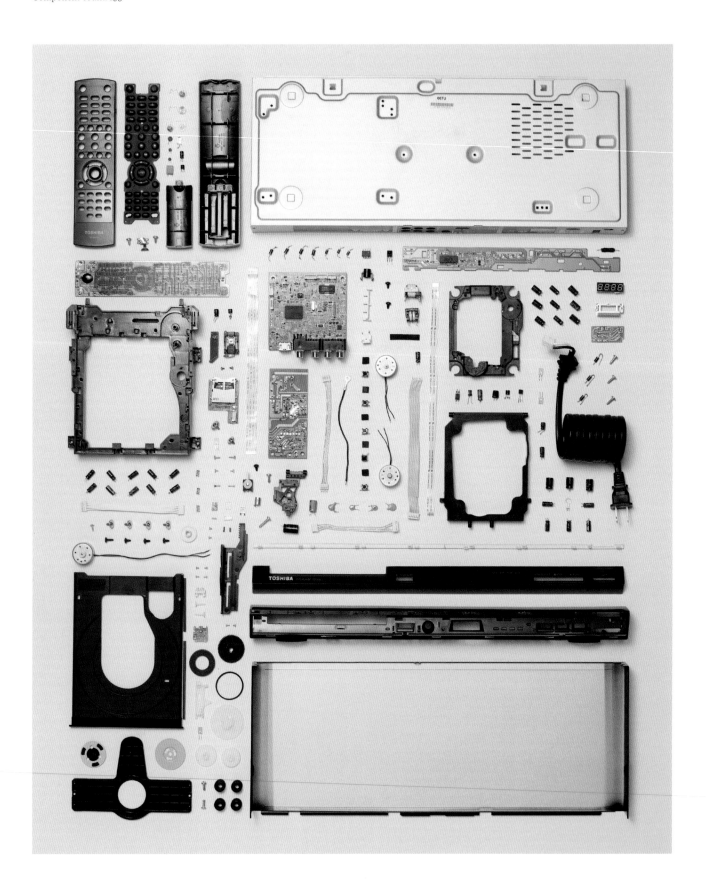

ECG Machine, 2014

General Electric
Component count: 273

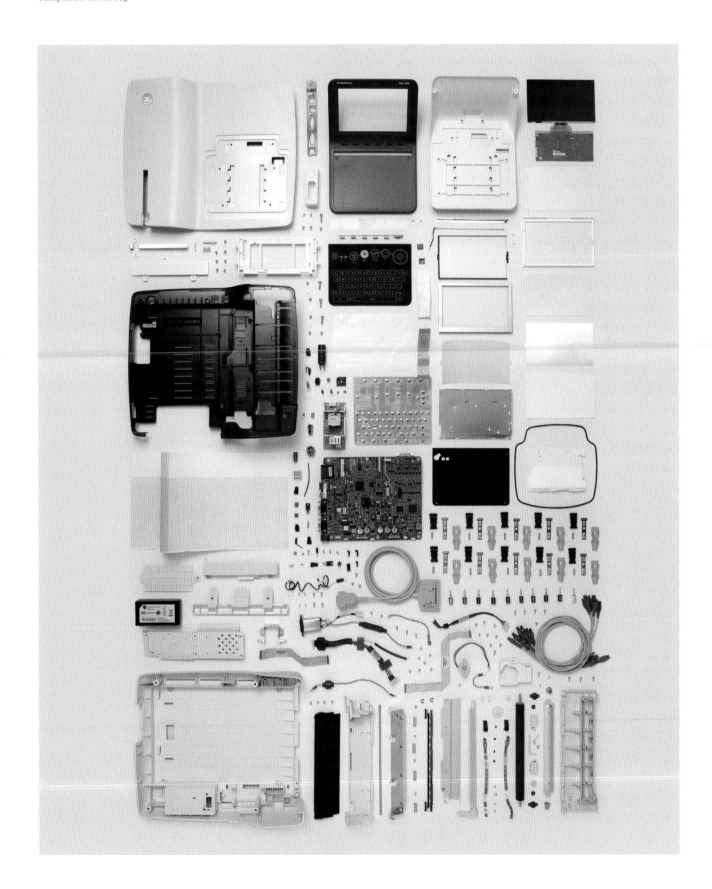

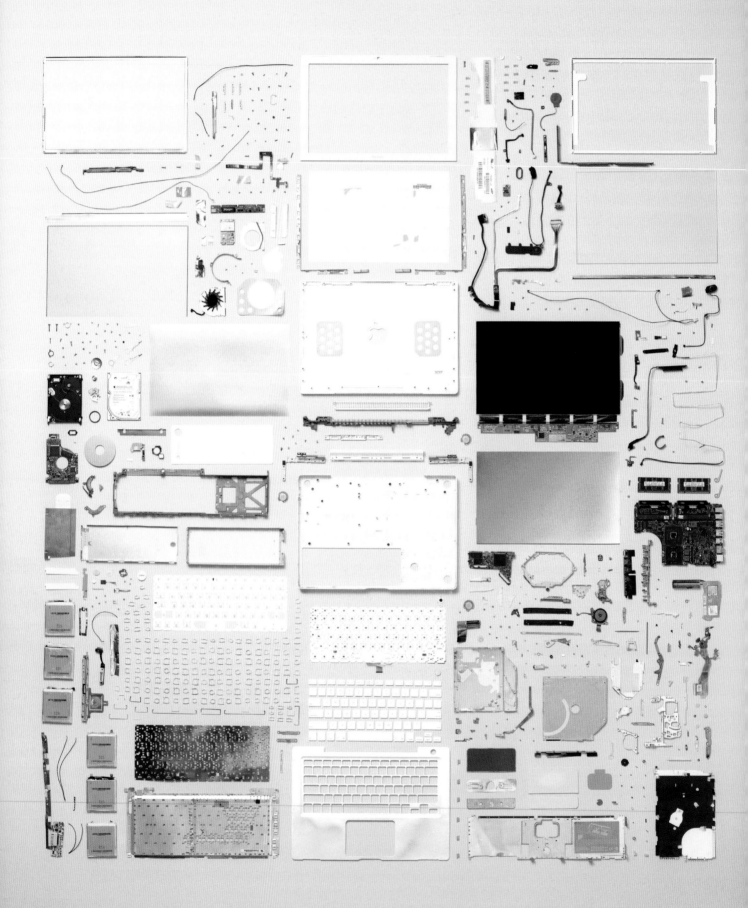

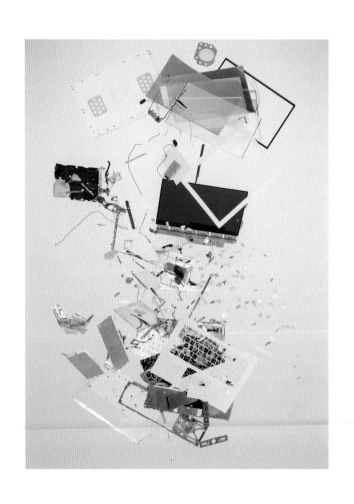

Laptop Computer, 2006

Apple
Component count: 639

Typewriter, 1964

Smith-Corona
Component count: 621

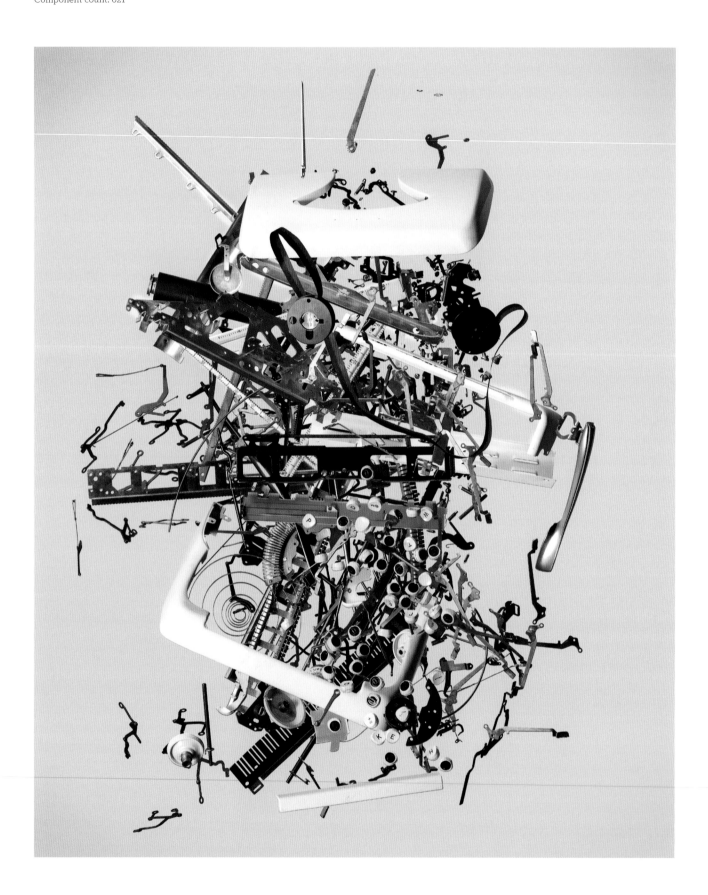

Typewriter, 1964

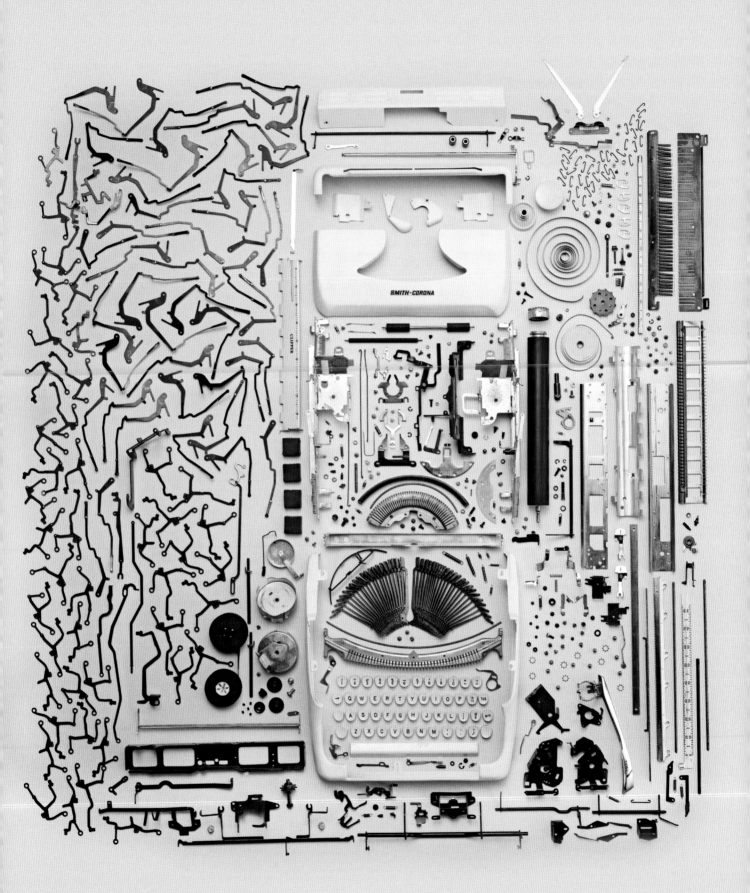

Printer, 2005

Epson
Component count: 532

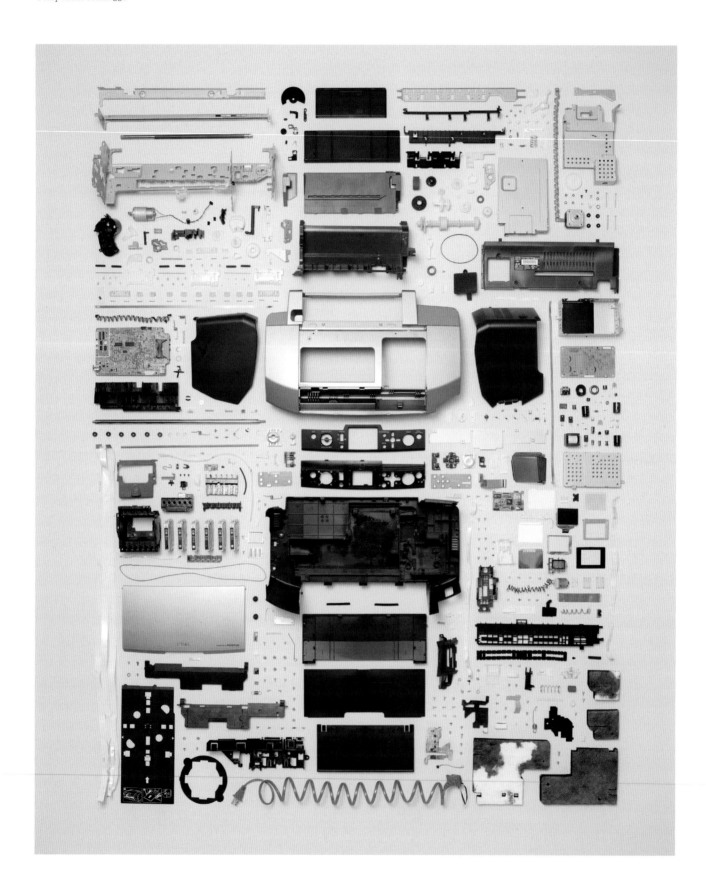

3D Printer, 2014

3D Systems
Component count: 679

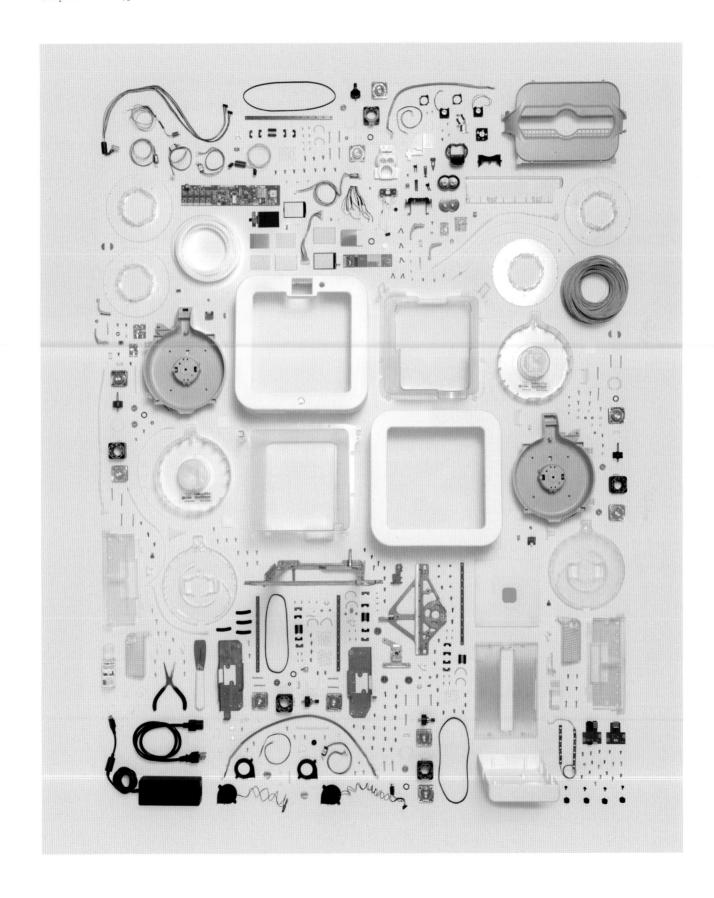

Gever Tulley, a former software engineer, is founder of Tinkering School, which runs week-long camps at which children learn how to use power tools to build, solve problems, manipulate new materials, and re-purpose old ones.

#2

LIFE LESSONS LEARNED THROUGH TINKERING

Tinkering School began around ten years ago when I realized that the formative childhood events of my generation just weren't available to children any more. First-time parents I knew would say, 'Well, I barely survived, so I can't let my children go and play in the woods, or use tools in the garage.' At a dinner one evening I said, 'I should open a summer camp where kids can come and be kids and just use some tools.' I ended up with six kids signed up over that dinner conversation and a sort of commitment to a date that summer. It was the best mistake of my life. At the time, I had a very good job in the computer industry, I was managing an innovation group at Adobe and really enjoyed what I was working on, but that discussion was like a pivot in my life, just as for other people it might have been getting married or having children of their own.

Eight children were signed up by the time the summer camp started, and I had cleared the downstairs rooms in my house and turned them into dormitories. Since then the idea has grown into something much bigger, with independent tinkering schools in Chicago, Austin, Buffalo, Baltimore, Malibu and Los Angeles, and another just started in Bratislava, Slovakia. Every year we grow our programme a little bit more. We started with one session per year, now we run five sessions, ten kids each, making fifty kids, and we have around 480 applications for those fifty spots. Parents clearly have a deep desire to hand over their kids to this crazy guy in California. Kids come from all over the world.

California is a very entrepreneurial environment, and that helps. It's a shock to me sometimes that people don't feel empowered to run with their idea and see where it goes, instead of carefully plotting every step and making sure that everything is going to be okay. If you just run off and make the very best version of an idea with what you have, you are in much better shape to figure out whether that idea is viable or interesting or going anywhere. Don't try to make it perfect, just make it as good as you can.

At Tinkering School we set up engaged learning experiences where children take on a challenge that was clearly outside their 'comfort zone'. We don't handpick children who knew basic engineering, or anything like that. Often it is their first time holding a pocket knife or using a power tool. We are on very short deadlines and giving them very complex challenges. We might say, 'Let's build boats, and we're going to put them in the ocean on Wednesday and power them around.'

We're kind of famous for the eight- or ten-hour days that the kids work. We break for meals, and we rush back up to the barn. The children are so much more ready and raring

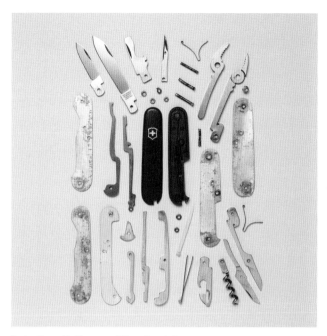

Swiss Army Knife, 1990s | Victorinox | Component count: 38

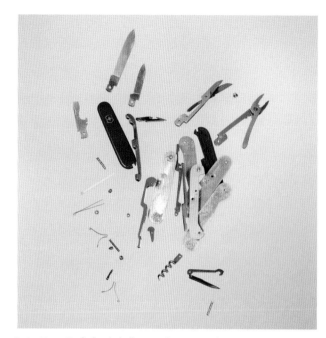

Swiss Army Knife (exploded), 1990s | Victorinox | Component count: 38

to go than the adult collaborators working with them. The projects enable the children to integrate lots of disparate skills that they've learned in school – finally

> 'Let's build boats,
> and we're going to put them
> in the ocean on Wednesday
> and power them around'

they have a place to apply a little bit of mathematics and art and a little bit of physics and to put them in a context that makes sense. It was amazing to watch how they really enjoy struggling with hard problems and having successes and failures. We wonder, 'if this is holding their attention in this way and they are working so hard at it, why isn't regular school like this?' Parts of the programme are consistently successful but not always; so then we stop to ask, 'what exactly were we hoping for?' We look at our failures and start tweaking and trying out new ideas.

To give you an idea of what Tinkering School does, I recently asked the children, 'Do you think we could make sail-powered railcars?' About a forty-five-minute drive from

the school there is a bit of recently abandoned railway track. Checking out the materials we had, we made a special late-afternoon shopping run to get some new wheels that would work on a railway. By the end of the week we had these beautiful vehicles – we called them 'railboats' – just simple platforms with quite big sails and a variation of sailboat rigging that the kids invented. The plan was to drop off the 'boats' at one end of the railroad track and pick them up at the other, 11 miles away.

Not all of the railboats made it all the way down the track. Sometimes the way the children had mounted wheels didn't work out and they came apart. The railway itself, previously used for transporting gravel and sand to a concrete factory, was in poor shape. Despite that, one railboat made 5 miles, one covered just 2 miles, but one made it all the way to the end. A child would be out on this lonely railroad with three or four new friends, with a limited set of materials that happened to be on the boat, trying to figure out how to hold on a new wheel or fix a broken brace. One group even ended up using duct tape to make a wheel that lasted about 3 miles. I think the project will stand the test of time as one of Tinkering School's greatest, just for its sheer poetic beauty. It was audacious, and an opportunity for the kids to think themselves out of a problem.

But we learn just as much from our failures. One time, we were looking in the US magazine *Make:* for a one-day project to slip into our complicated schedule. We chose a cigar-box blues guitar project, and in the morning it started out pretty well. The kids were really excited about the idea of everybody building their own guitar and we

It was a galvanizing experience for them to see the thing just come apart when you applied power.

were going to have a rock 'n' roll jam session at the end of the day – that was a pretty motivating destination. As we got going we found that the kids were most engaged when they had to deviate from the magazine's instructions. But about two-thirds of the way through, an unexpected emotional detachment came into play as the kids started to see differences between the guitar they were building and the one in the magazine. They could see that theirs was going to fall somewhere short of their expectations, and they were making judgmental comparisons. When we were done, we got some musical sounds out of these things, but the kids had realized it was kind of a foregone conclusion; there wasn't much left to discover or to invent or innovate on their part. We concluded that such projects don't leave room for the child's narrative, or the sense of discovery and ownership that you get when you've figured something out for yourself.

Failure doesn't inevitably lead to emotional detachment. We once made some little electric carts, using electric hand drills as the motors. The kids were going to drive them around holding the extension cord. We got some very big industrial drills intended for drilling holes in concrete but they were too powerful. They tore apart the little carts. We broke chains, we broke sprockets, it was amazing, they just self-destructed. The kids had worked very hard, they had learned how to weld, and it was the first time we had worked

with metal at Tinkering School. We had high hopes for these things, but they just couldn't withstand the force – the torque – from those drills. The kids were disappointed that they weren't zooming around on the electric carts that they'd built, but there was also something epic about that kind of failure. It was a galvanizing experience for them to see the thing just come apart when you applied power.

When it comes to components, we harvest parts from all kinds of things. One of the rules at Tinkering School is that we never use anything that a child might not find in a reasonably well-stocked home garage. However, one year we were driving the kids back from a beach outing when we spotted a pile of broken lawnmowers and lawn-maintenance equipment beside the road. We stopped and loaded all that mechanical, petrol-powered stuff into the back of the truck, drove home, and started sorting it out, stealing parts from one and the other. We got two of the motors working and then the kids built a car and a motorcycle out of the recovered parts and some old plastic pipe that they found under my shed. The pipe frame of the bike allowed it to twist almost forty-five-degrees due to the way the kids had built the chassis. As you went around a corner, the weight of the motor would sort of flop over to one side and it

The kids built a car and a motorcycle out of the recovered parts and some old plastic pipe.

would over-steer. It was very thrilling to drive. The project may sound insane, but it was not insanely dangerous. Tinkering School always has to assess risk and the parameters of safety, and kids also need to gain the skills of risk assessment and mitigation for themselves.

Tinkering is changing. A typewriter may have over 600 components while an iPad has only about 170 pieces, although many of those are smart components. Today, kids are watching YouTube videos and are often stumbling across great new ideas. One kid showed me a kind of water-

powered rocket that intuitively made sense but I'd never seen it before. People aren't toiling away in their garages in lonely silence any more; they use their phone to shoot a video of their results and put them on the Internet.

I am also encouraged by a new trend of parents and kids wanting to build things together. The digital age has led to a sort of collective constipation because nobody's making anything physical. Suddenly people are waking up and, while they don't quite understand the urge just yet, they need to make something. It was certainly true for me that, after years of working in the special-effects industry, putting beautiful pixels on the screen, I wanted to use my software skills to make physical things.

The same may prove true of kids who devote themselves to *Minecraft* or other products that allow them to build and share game environments. I think that, maybe after years of doing it, children who have lost themselves in that world will hit a point where they realize that 'nothing I have

I don't know whether game playing will support the desire to tinker or actually supplant it.

made is really real.' Some of these young children have come to understand very sophisticated engineering ideas through playing games like *Minecraft*, but I don't know whether gaming will support the desire to tinker or supplant it. Doubtless dozens of research papers will be coming out about this topic over the next five years.

When you are tinkering with physical objects, with a design in your head and a pile of parts in front of you, your ideas intersect with reality. The materials demand compromises but also provide new opportunities. Kids might get something like a broken printer and take it apart until they have separated all the constituent parts. While taking it apart they are in a sense exploring another person's ideas. It's almost like having a conversation with the designer

about the physical, economic and marketing constraints that influenced his or her design decisions. The kids might notice that an early decision forced the designer to create a convoluted, weirdly shaped lever to get paper-sensor information transferred mechanically over to another part of the printer. Then they come across an assemblage, apply a battery, and get a little motor going. Reviving a motor can be as exciting as bringing Dr Frankenstein's monster to life.

Children are willing to explore an intellectual or physical landscape for no other purpose than to see what's there and what's possible. Adults carry a lot of social and emotional baggage: they are expected to be productive, on-task, and to get things done. Parents find programmes like Tinkering School appealing because it is hard for them to find time to spend two days taking something apart, just to see what is in it. Yet the processes of disassembling something, or building something with a limited set of materials, are what lay the foundations of creativity.

Parents often say to me, 'I want to help my child learn some tinkering skills, or learn how to take things apart,' and ask, 'where should we start?' Well, I think we should be giving kids pocket knives again. A pocket knife is an amazing, empowering, universal tool, and with just a couple of ten- or fifteen-minute sit-downs with a child to talk about the safety parameters, it can be an entirely wholesome, productive experience for them. They can use it to take something apart, whittle away at something, cut a piece of paper, or prise something open. It is the ideal tool for unlocking the universe. It offers a way of gaining a little bit of mechanical competence, a little bit of hand–eye coordination, and a way to shape the world to your ideas.

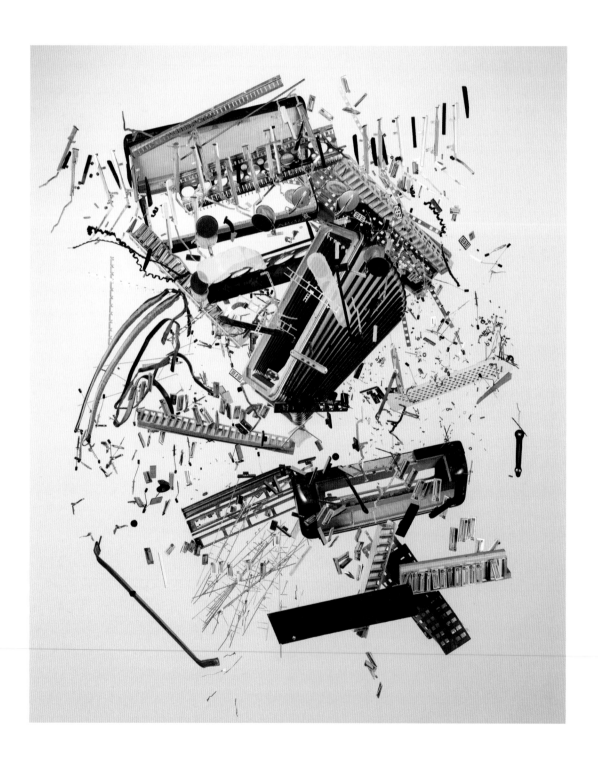

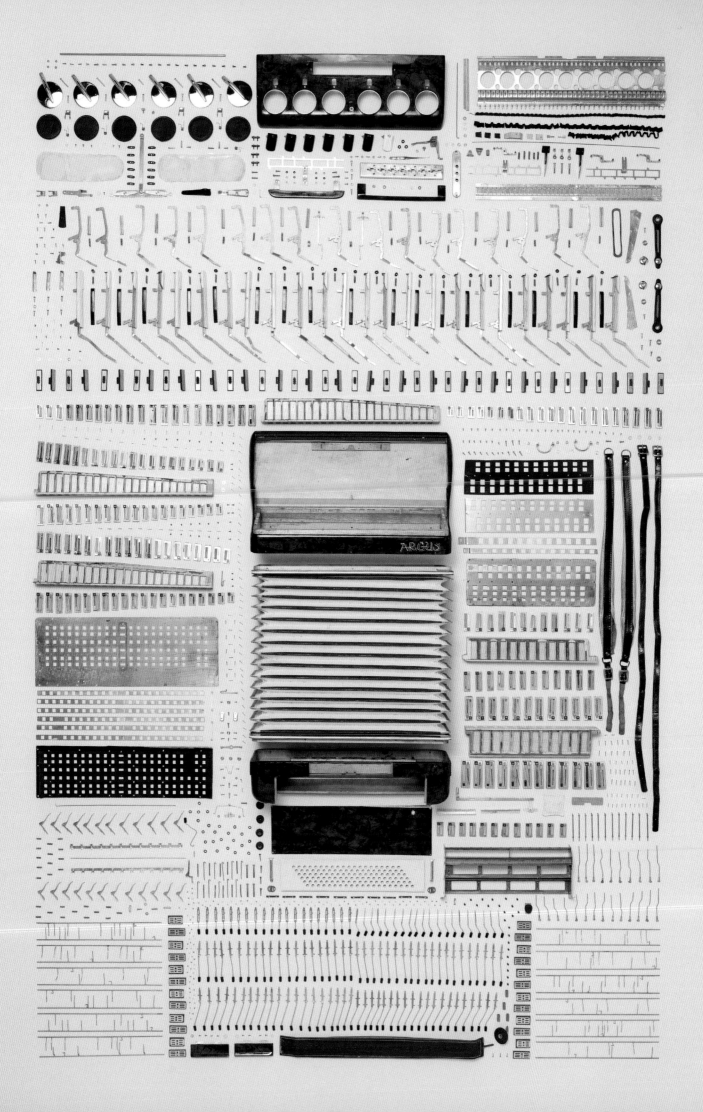

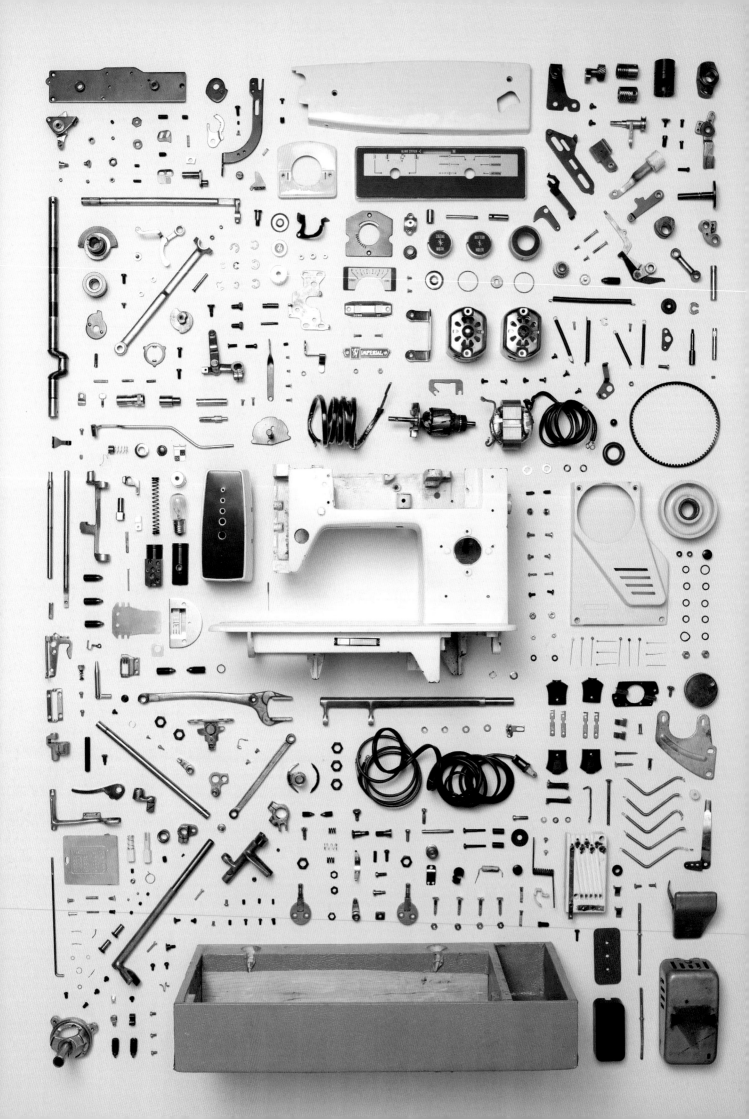

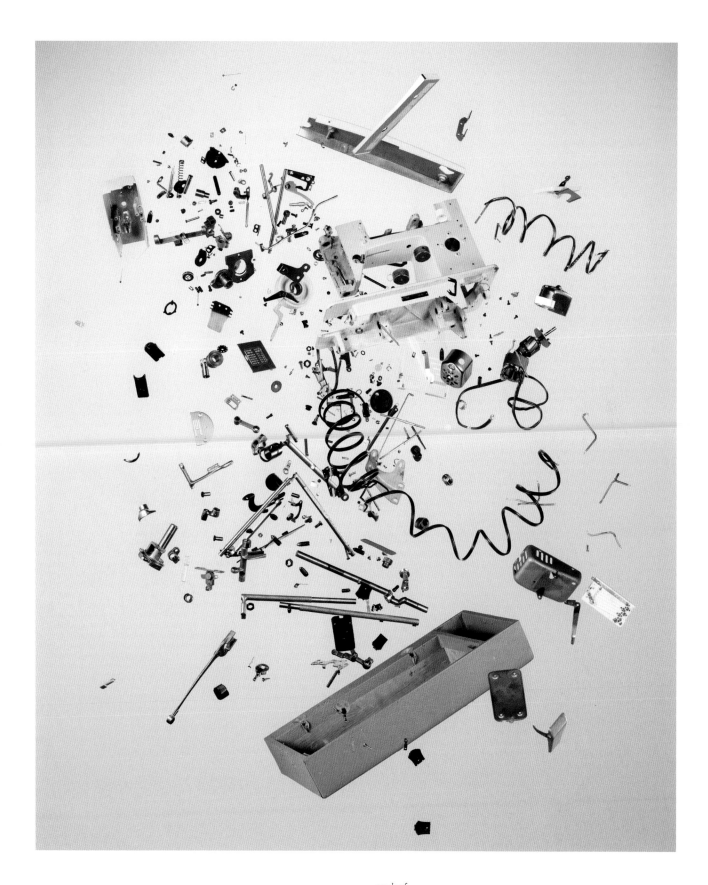

Sewing Machine, 1970s

Imperial
Component count: 482

overleaf:
Chainsaw, 2010

Stihl
Component count: 297

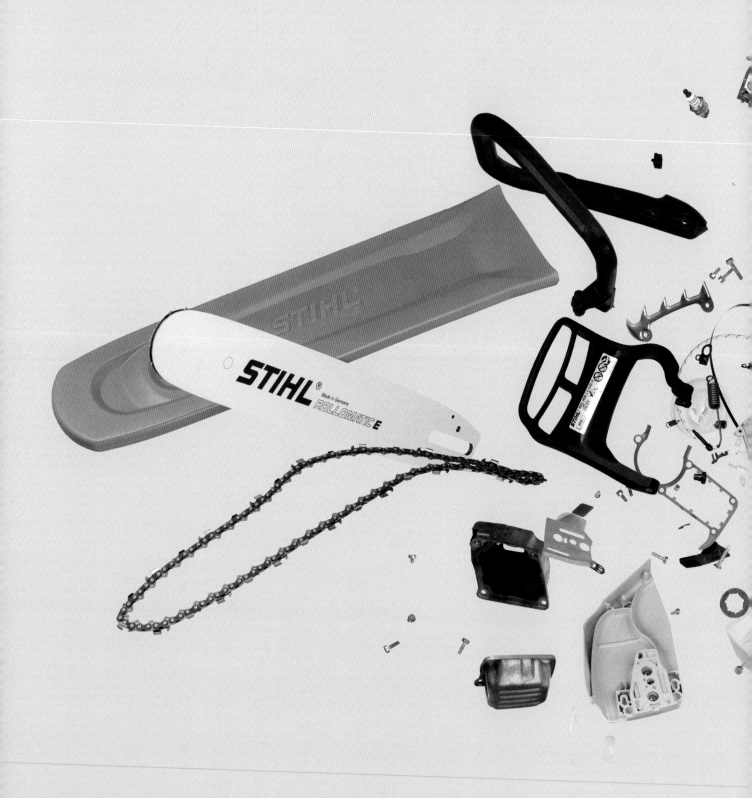

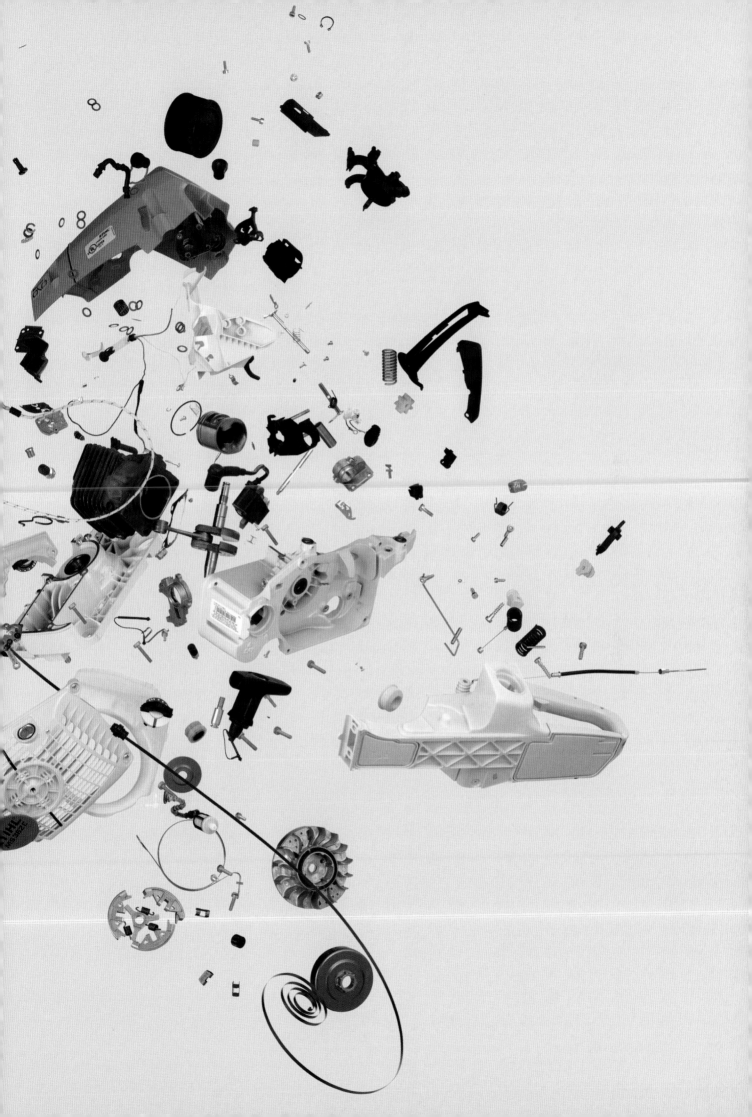

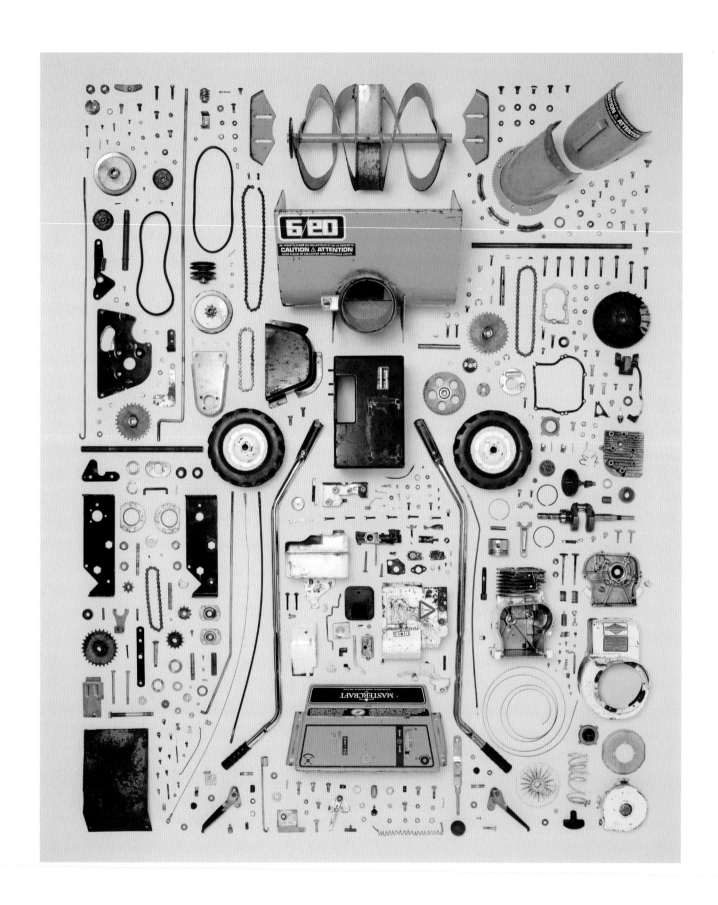

Snowblower, 1970s

Mastercraft
Component count: 507

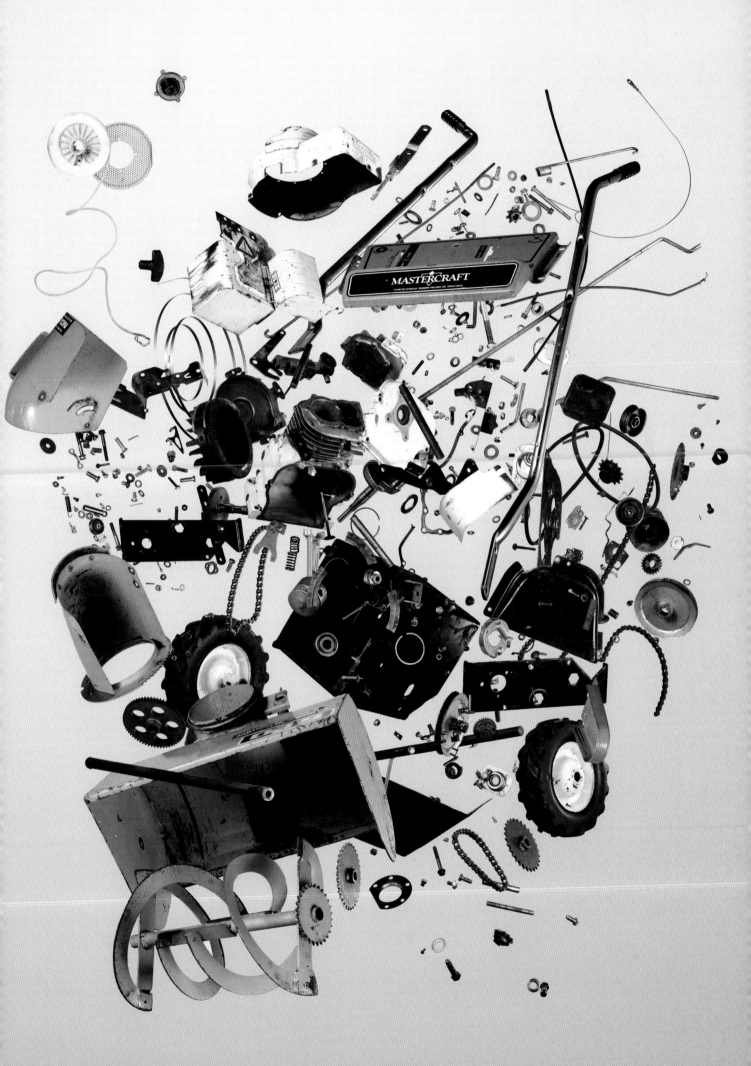

Keyboard, 1999

Optimus
Component count: 178

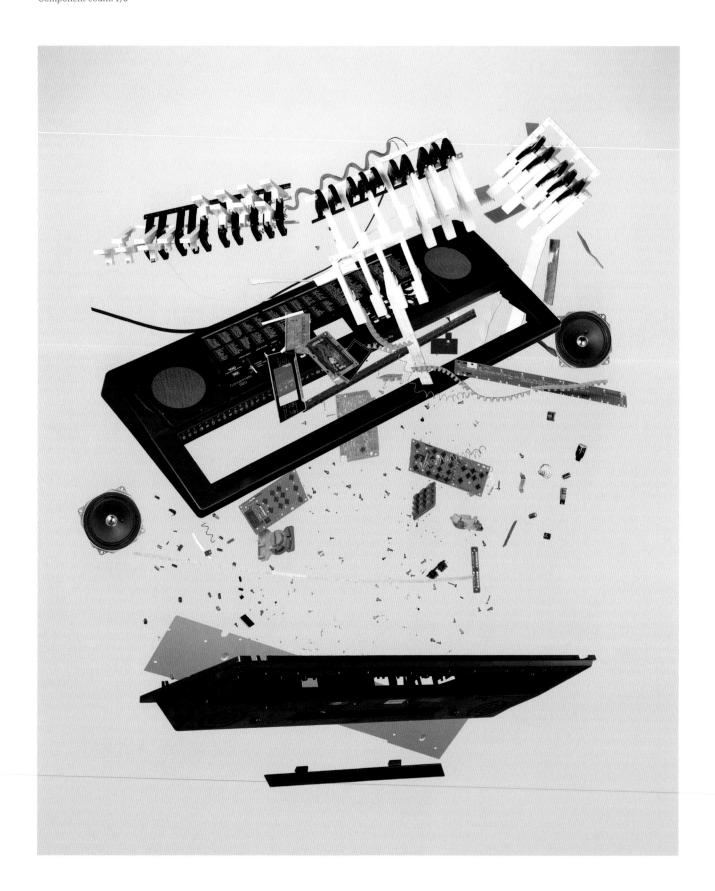

Keyboard, 1999

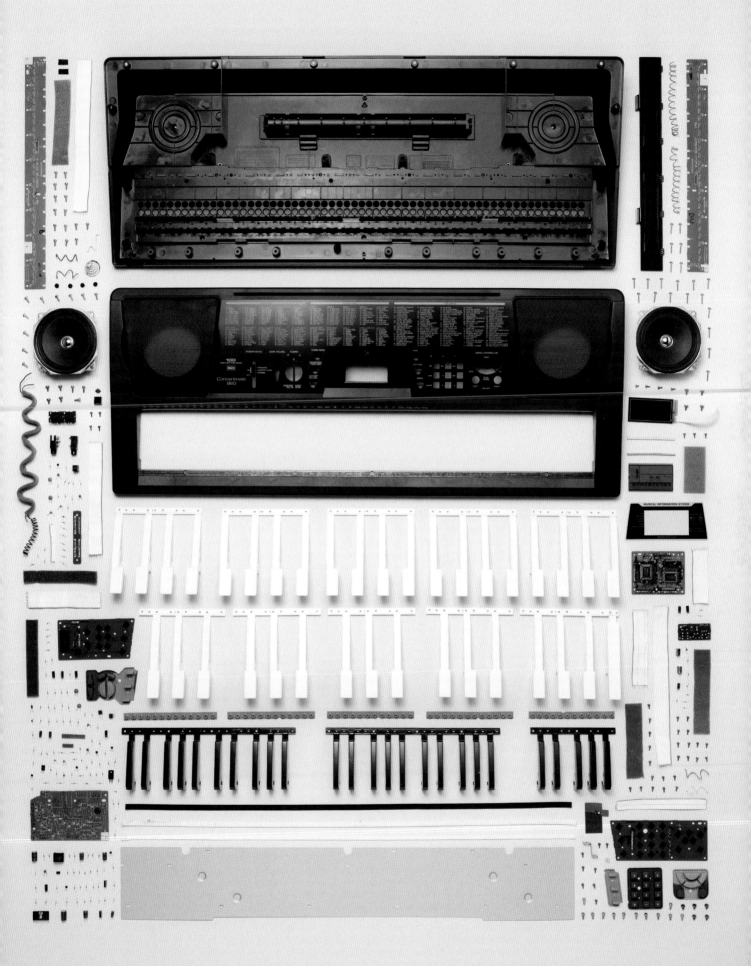

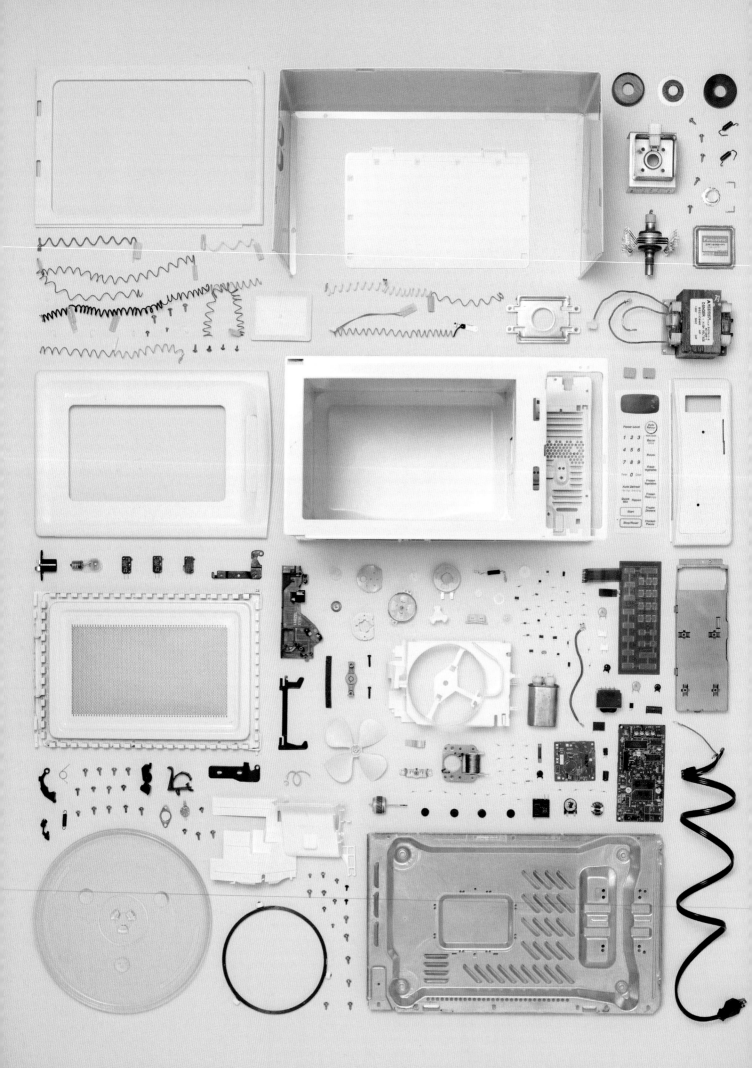

Microwave Oven, 2005

Panasonic
Component count: 212

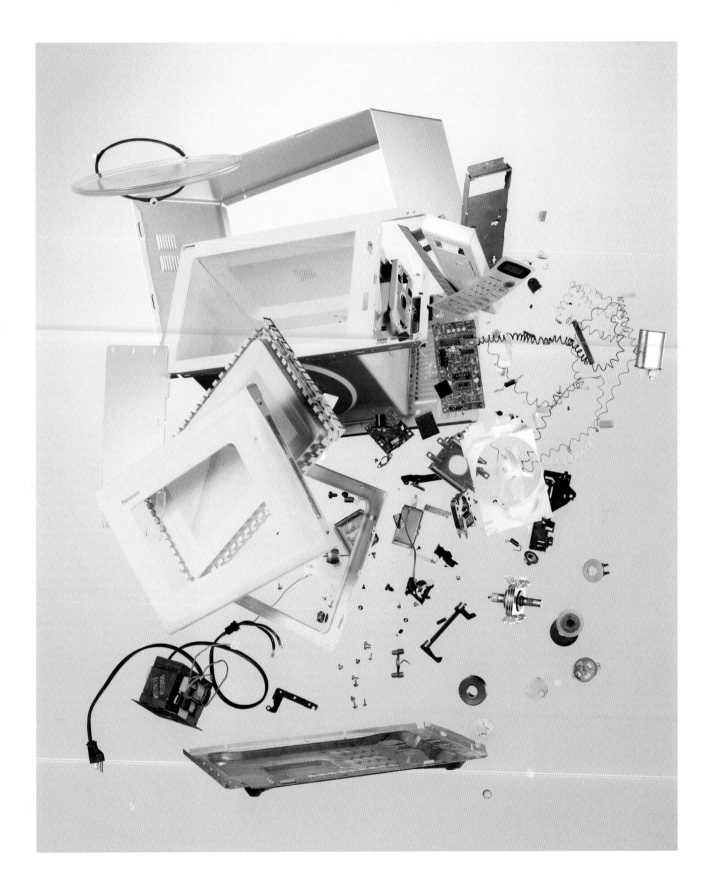

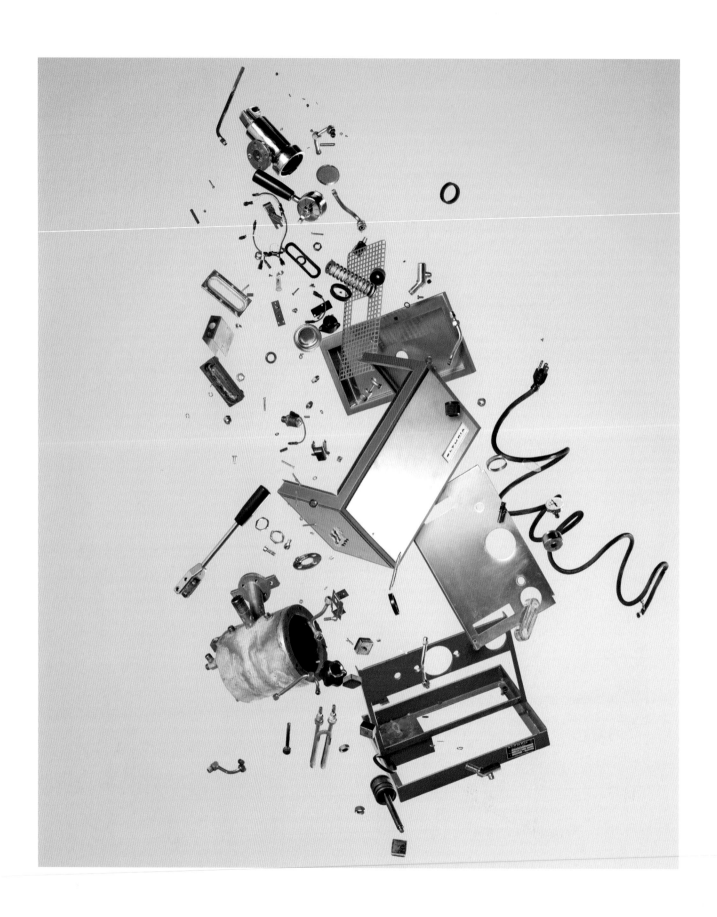

Espresso Machine, 1970s

Olympia
Component count: 212

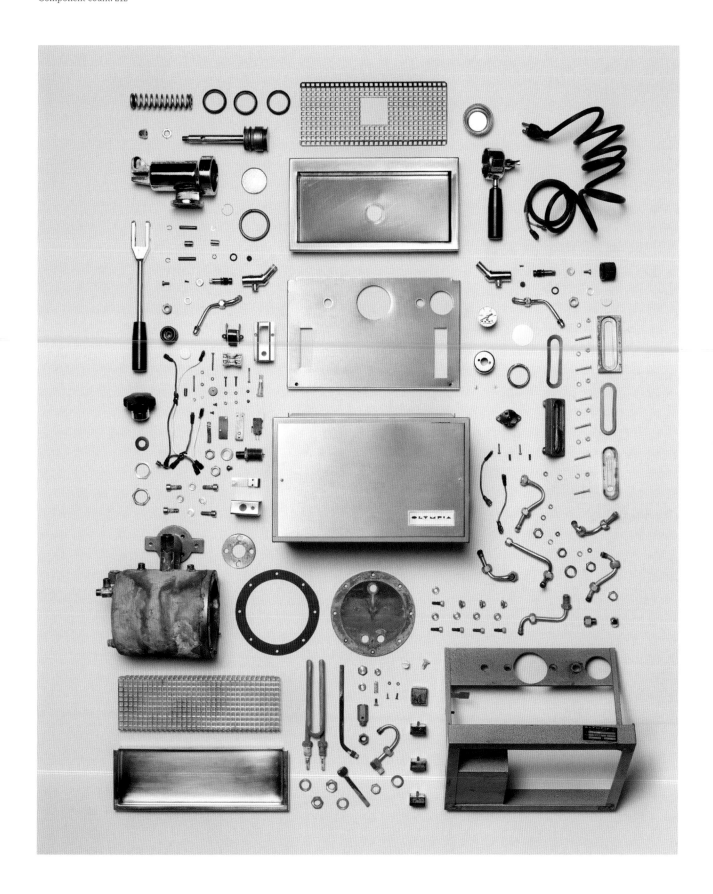

Toilet and Cistern, 2008

Crane Plumbing
Component count: 72

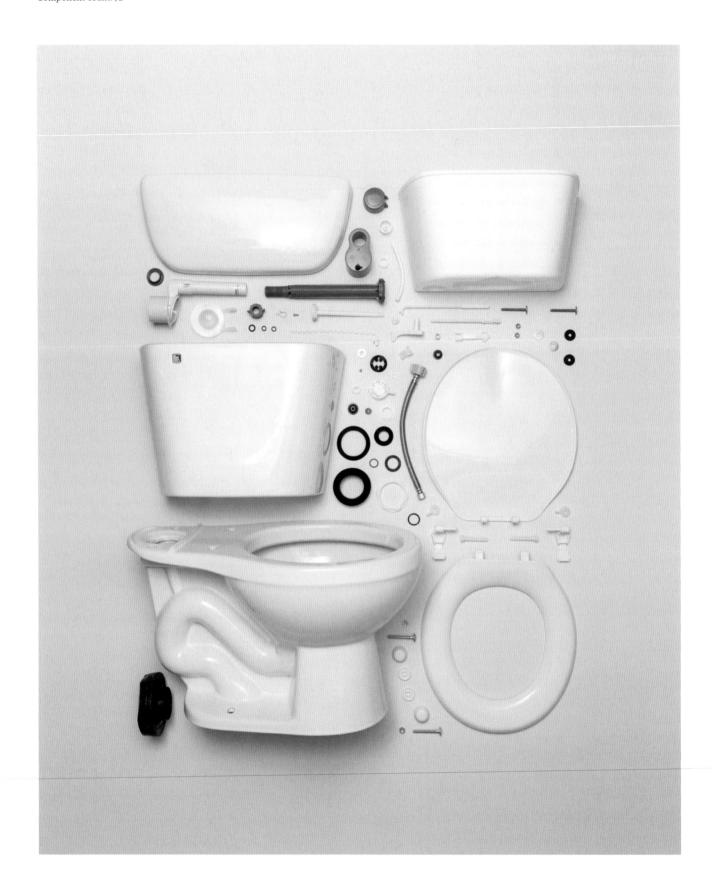

Toilet and Cistern, 2008

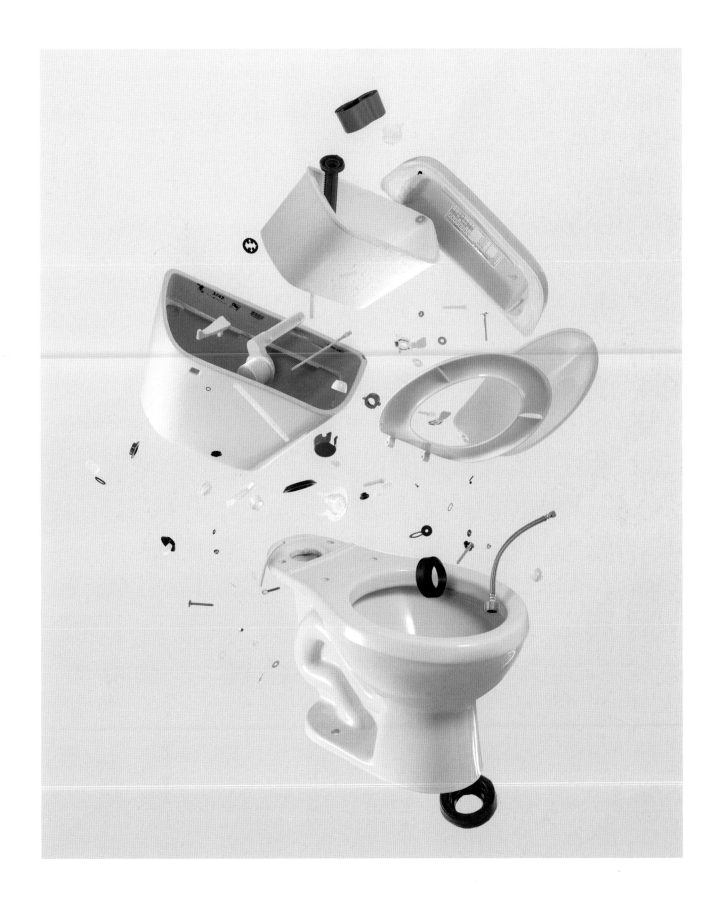

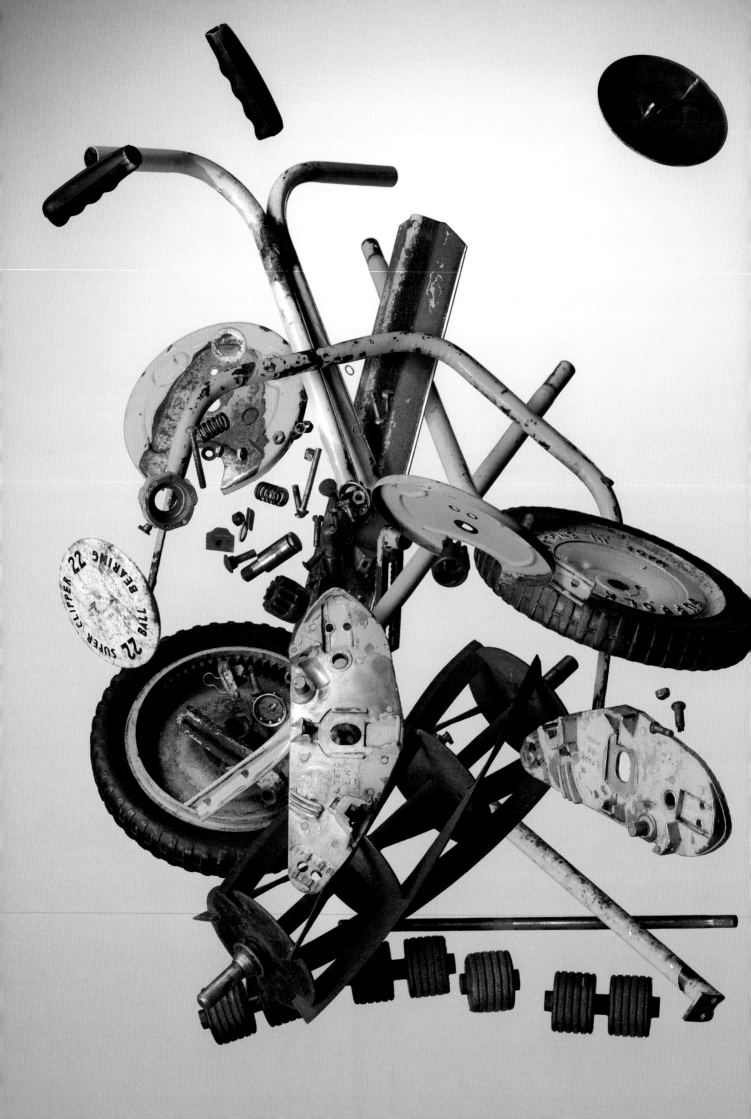

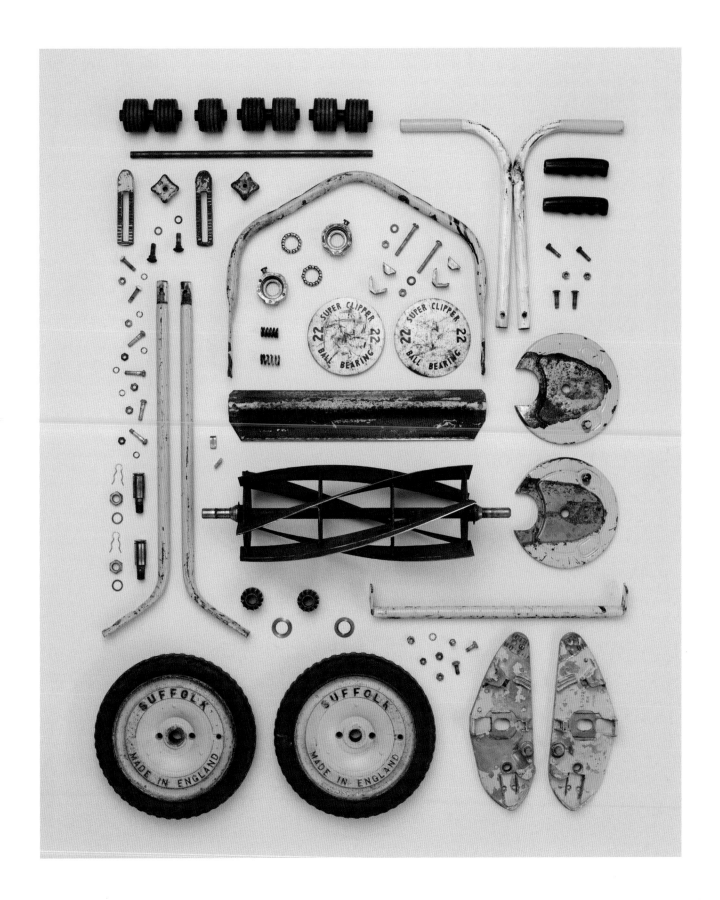

Push Lawnmower, 1970s

Suffolk
Component count: 92

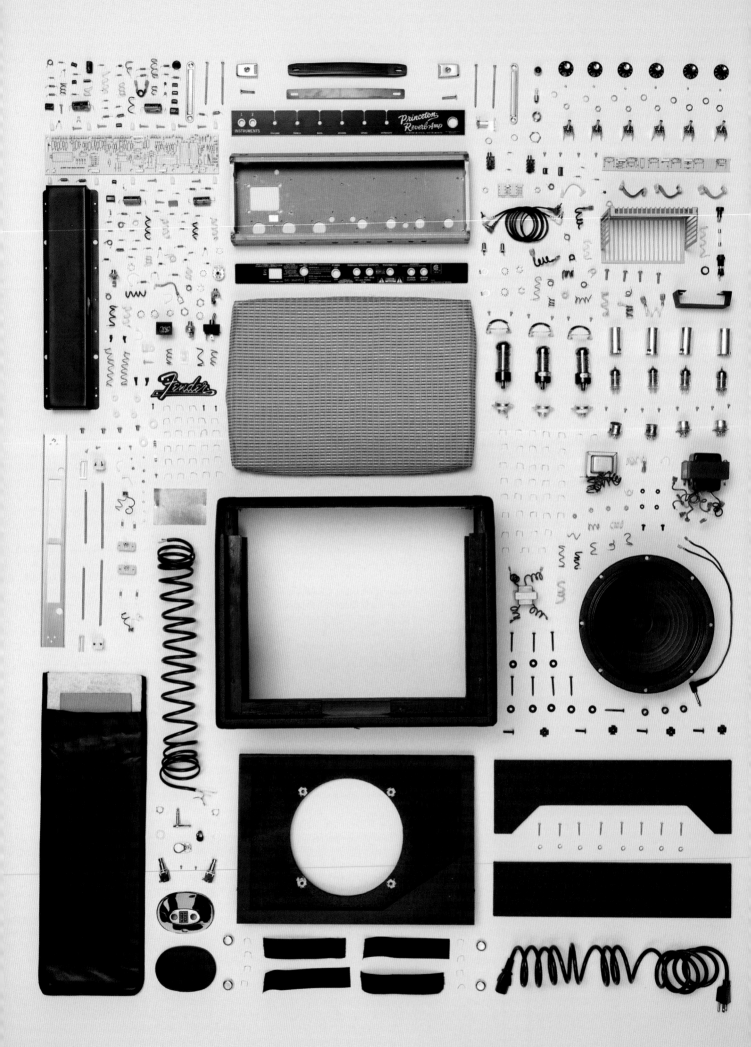

Amplifier, 2008

Fender
Component count: 529

ATM, 1997

Triton
Component count: 930

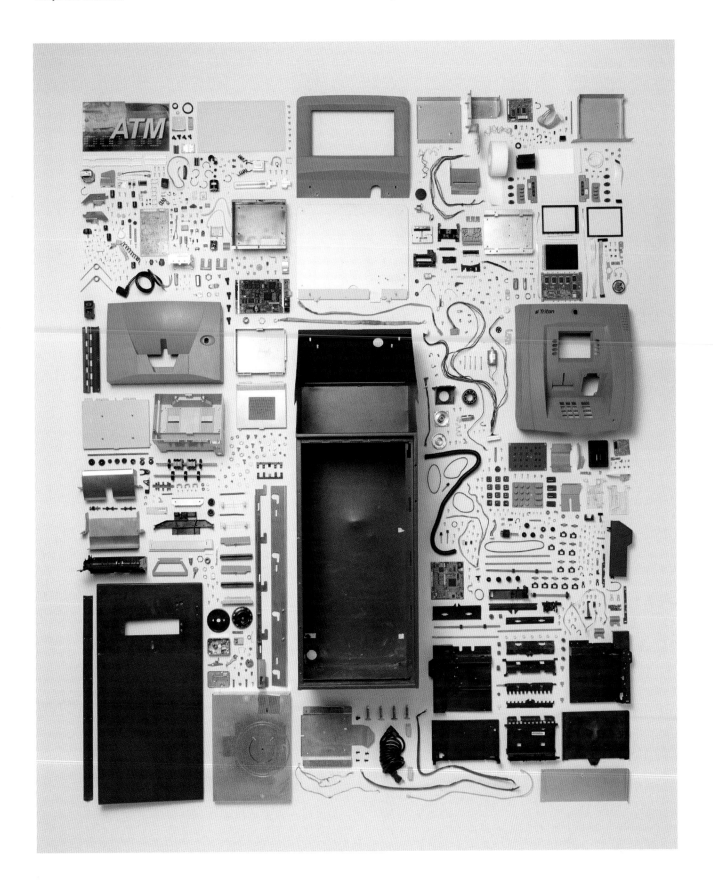

Penny Bendall is a ceramics conservator who has restored artefacts from private and public collections around the world from the seventh to the eighteenth century.

#3

TAKING APART THE PAST

In January 2006, a forty-two-year-old man was ascending the majestic Courtauld Staircase in the Fitzwilliam Museum, Cambridge, UK, when he allegedly tripped on his shoelace and fell headlong into three seventeenth-century Chinese vases on open display in the large window embrasure. The impact of his fall caused the vases to smash into hundreds of shards. The story quickly made international news following the release of a photograph taken by a member of the public with their mobile phone seconds after the incident had taken place.

I was the conservator employed by the Fitzwilliam Museum to sort out the jumbled shards and reassemble the three vases – a painstaking project that took an entire year to complete. Having studied Fine Art at Goldsmiths College, London, and then Brighton, I re-trained as a conservator at West Dean College, Sussex, and gained practical experience working for clients at an English country house on an important yet neglected collection of Sèvres, Meissen and Chinese porcelain. This was followed by a stint working in situ in the blue-and-white porcelain room of the Charlottenburg Palace, Berlin, which had been damaged in World War II. In 2003 I was granted the Royal Warrant to Her Majesty The Queen and, as a result, I now work regularly on the ceramic collections in Britain's Royal Palaces. I have experience of conserving all types of ceramic fabrics (from unfired or fired earthenware and stoneware to soft- and hard-paste porcelains) dating from the second century BC to the late twentieth century.

My approach is unique to every project and depends on the material involved: earthenware, for example, is treated very differently from porcelain. When undertaking conservation for a museum, having ascertained the material of the piece and consulted relevant curators, I devise a project plan that is then executed in consultation with them, and modified as necessary as work progresses.

In some cases, especially on archaeological excavations, a conservation project might first involve laying out fragments and categorizing them. In other cases, a piece may actually be virtually intact but still in need of conservation. I was recently asked to work on 'The Maypole Group' made in the eighteenth century by the Chelsea porcelain factory, London, and on loan to the Fitzwilliam Museum. Although the piece was intact, previous restorations had become discoloured over time, and were unsightly. Moreover, old adhesives were starting to fail, meaning that the item was in danger of becoming unstable. After further examination in the laboratory, and a campaign of pre-conservation photography, the decision was made

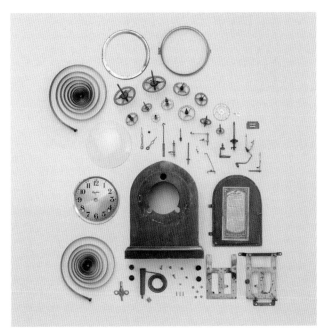

Mantel Clock, 1928 | E. Ingraham | Component count: 59

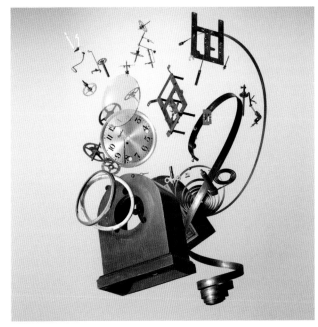

Mantel Clock (exploded), 1928 | E. Ingraham | Component count: 59

to take the group apart in order to effect a complete programme of conservation according to modern standards.

> Disassembling a work of art offers an unprecedented opportunity to learn more about it.

The project was particularly complicated because, although there was no written evidence recording earlier repairs, visual examination and technical analysis revealed that the Chelsea figures had, in fact, been restored numerous times in the past. One technique employed by conservators to analyse an object before it is disassembled is the use of ultraviolet light, which reveals the presence of adhesives, fills and over-paint. While areas of restoration and weakness in an object are usually evident to conservators, photographs taken with ultraviolet light provide a valuable record of objects while still intact. Such photographs can be useful in unexpected ways. I remember working on one particular vase that, once apart, turned out to be a pastiche of five different vessels, and the ultraviolet

photographs provided an invaluable historical record of how those disparate elements had been married up.

On disassembly of the Chelsea group I made the unexpected discovery that this was also a pastiche with elements made from at least one different porcelain having been added to the original. It seems that previous restorers had replaced missing elements, such as arms and feet, either with replicas crafted by themselves or with pieces taken from other works, which they simply glued on. Moreover, glazed porcelain flowers had been attached with a variety of adhesives and plaster cushions over firing cracks and earlier breaks to mask them from view. Whether these flowers are original or later additions is difficult to ascertain, but judging from their diverse styles, a combination is most likely.

Disassembling a work of art offers an unprecedented opportunity to learn more about it in terms of how it was modelled, fired and glazed, and its subsequent history. For example, I discovered the original support columns inside the base of the Chelsea group, which no-one knew existed. All the disassembled parts are carefully labelled and documented via written records and digital images. Without meticulous record-taking, such discoveries of how a work was originally made are easily lost.

Unlike the smashing of the Fitzwilliam vases, the disassembly of the Chelsea group was intentional and carefully controlled, but ironically the effect created was equally if not more dramatic. Colleagues witnessing the group being disassembled into its numerous constituent pieces found the process both intriguing and alarming,

...matching up structural details...may be the only way of reliably working out how the shards fit together.

although all I was doing was removing old adhesive. When laid out on the bench in the conservation studio, the pieces were almost like a work of art themselves, and the transformative process of deconstruction and reconstruction was fascinating. I enjoyed being the creative agent responsible for turning a three-dimensional object into an assembly of parts, and then back into a three-dimensional object, albeit in a revised (i.e. properly conserved) form. Seeing artworks disassembled takes people out of their 'comfort zone' because they are conditioned to seeing them whole: 'fragmentary' is equated with 'broken' or 'damaged' and it appears to be especially problematic (i.e. psychologically disturbing) for people to see a human figure in pieces.

Although I am a trained painter, I find it more rewarding to work on three-dimensional objects than on flat art. In cases where an object is fully documented, deconstructing and reconstructing is relatively easy, and it is always easier to reassemble a piece if one was also responsible for its disassembly. I sometimes get asked to reassemble a ceramic piece from fragments. If there is no record of the item's original appearance, deciding on the order of reassembly can prove challenging. If the original pattern is still visible, this can help, but one has to be aware that it may have been incorrectly over-painted subsequently, and sometimes the pattern has completely worn away.

In such cases, matching up structural details such as the ribbing on the inside of a piece may be the only way of reliably working out how the shards fit together.

The process of disassembly and reassembly is also fraught with ethical issues. In the past, decorative pieces were often reassembled with non-original additions to make them appear complete and easier for the public to digest visually. If such a piece undergoes conservation, it must be decided (ideally by the conservator in conjunction with the owner of the piece) whether or not to keep non-original additions. In the past, such non-original additions may have been considered 'irrelevant later add-ons' and discarded, but nowadays a more cautious attitude prevails. After all, non-original additions (especially when documented) are integral to the history of the piece and can tell us a lot about the taste and priorities of a given historical period.

Moreover, the new reassembly has to be reversible. All adhesives will fail in the end and most will discolour over time, so it is vital to choose the correct adhesive: one that has appropriate strength for the ceramic body being conserved, good longevity, no or minimal discoloration over time, and also one that, if necessary, can be removed without problem in the future.

...'invisible' restoration is completely wrong and... the restored areas of a piece should be easily identifiable.

Conservators have a responsibility to the object they are working on, and need to know when to hold back, stop and let an object 'speak for itself'. They also need to be aware that using the wrong material to effect repairs can spoil an object irretrievably. For example, in ceramics it is essential to use an adhesive that is suited to the object in question. While there are standard adhesives for hard-paste porcelain and earthenware, there are several options available for other types of ceramics, and the conservator

Taking apart the past
and reassembling it for
future generations is a
question of empathy...

must make a judgement call, based on experience and on the specific object, as to which particular adhesive is used.

Missing pieces are a further challenge to the conservator, as visible losses can detract greatly from the beauty of a piece, and its public reception, but there are ethically acceptable ways of dealing with such problems. One technique is to model some or all of the missing pieces afresh in a suitable material to recreate the profile, which is especially important in archaeological ceramic research. The newly inserted pieces are then painted an unobtrusive (normally matched) colour to set off the original decoration.

In the past, ceramic shards from several vessels derived from a particular archaeological site were often assembled as a composite piece, sometimes with the edges ground away to ensure a good fit. It may be possible to distinguish the various components through variations in colour or texture. A conservator faced with conserving a vase comprising shards from four or five different vessels has to decide whether to leave the vessel as is (as an example of archaeological practice of a certain period) or to remove certain mismatched pieces. In cases where non-original shards severely compromise the understanding and/or appreciation of the piece, it may be preferable to remove them. However, in examples of uncommon ceramic forms, it might be deemed preferable to retain all or some of the non-original shards if their presence conveys greater information. When, for example, an Islamic bottle vase that has been displayed for decades as a complete object, but on restoration is discovered to be a pastiche comprising the top of one vase and the bottom of another, the two parts might be re-displayed together to illustrate the distinctive profile of a complete vase, but with a sufficient gap between the top and bottom to demonstrate very clearly that they are not from the same object. In this way, conservators can

offer alternative display options to help curators decide on the best way to present individual pieces.

Having cleaned and reassembled the pieces of a work of art, the conservator must decide how closely the surface or 'finish' of the original object should be replicated. A conserved work cannot be re-fired as this would change the molecular structure of the original, reduce its commercial value and risk damaging the object by altering its surface or even causing it to explode. In the past, conservators tended to cover cracks to make the piece appear 'perfect', but now conservation ethics demand that flaws, cracks and repairs are not eradicated from the record: a conservator's work needs to be discreet yet evident on close examination. In my work, fills and retouching are done only when necessary to secure the physical integrity of an item.

I believe that viewers' increasing acceptance of and interest in such 'historical flaws' represents a step forward in both conservation and connoisseurship. In my lectures on ethics and conservation I explain the ethical decisions that conservators must make on behalf of their clients – the buyers and sellers of historic artefacts – and the important role that those clients themselves play in the process.

To be a professional conservator in the current climate requires a high level of ethical awareness: an ability to judge each project individually with good reasoning, practice and implementation. Critical factors to consider are the longevity of the treatment and materials used and honesty in the interpretation of the original in order to guarantee the survival of the object for future generations to enjoy and study. Although X-radiography, ultraviolet photography and various analytical methods are becoming increasingly important in conservation procedures, hands-on skills, experience and visual sensitivity are still paramount to the success of a project and, in my opinion, remain the most important conservation tools.

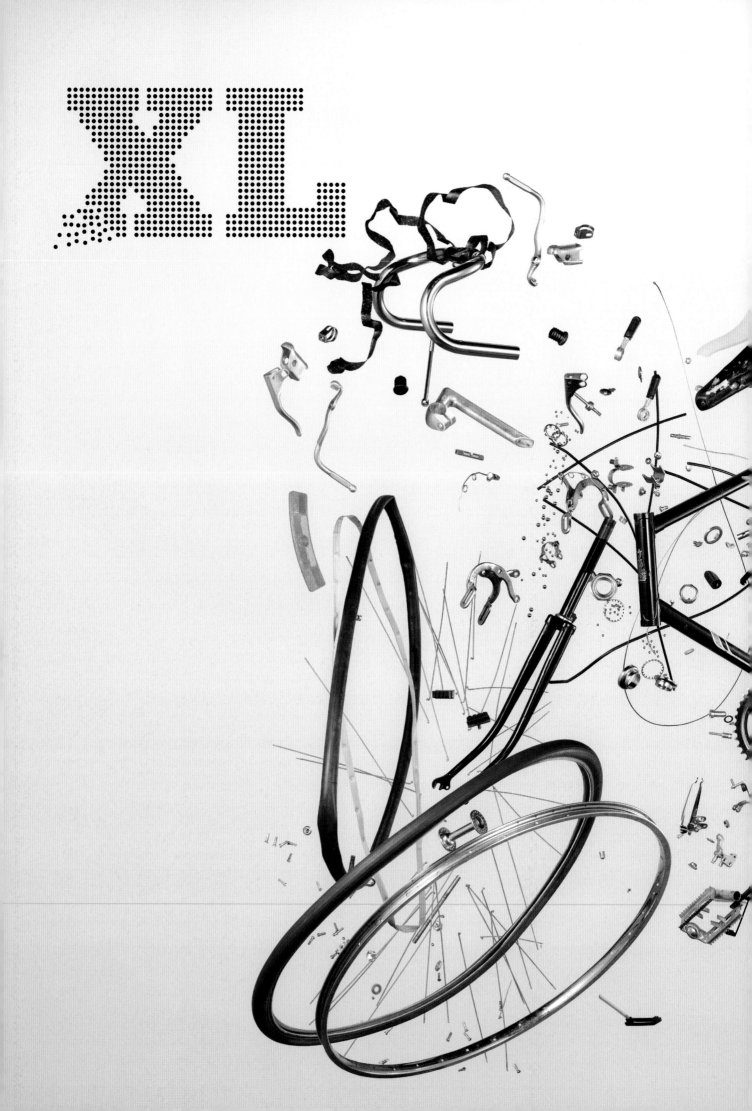

XL

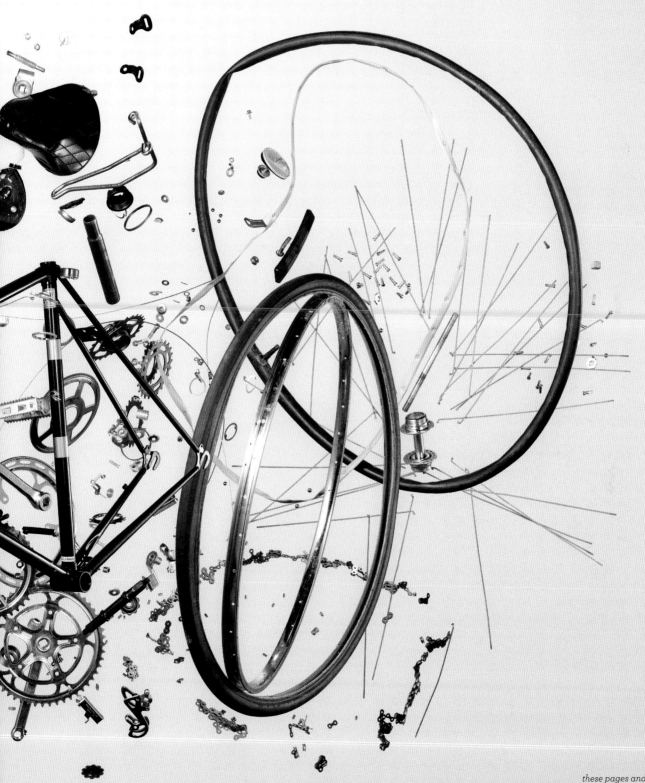

these pages and overleaf:
Bicycle, 1980s

Raleigh
Component count: 893

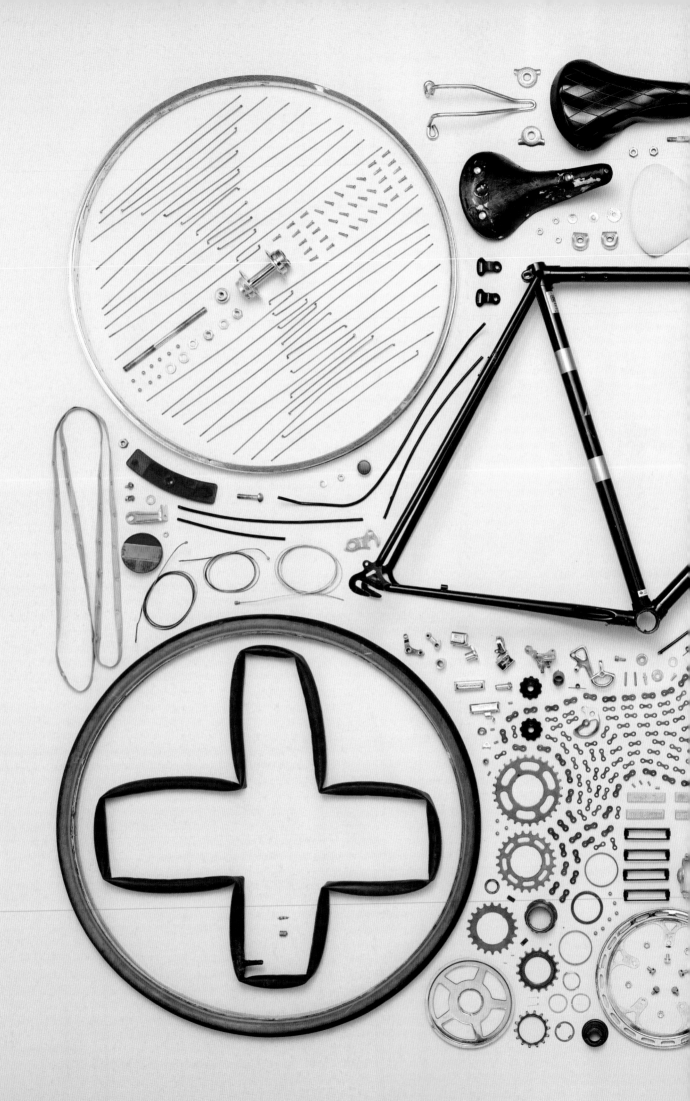

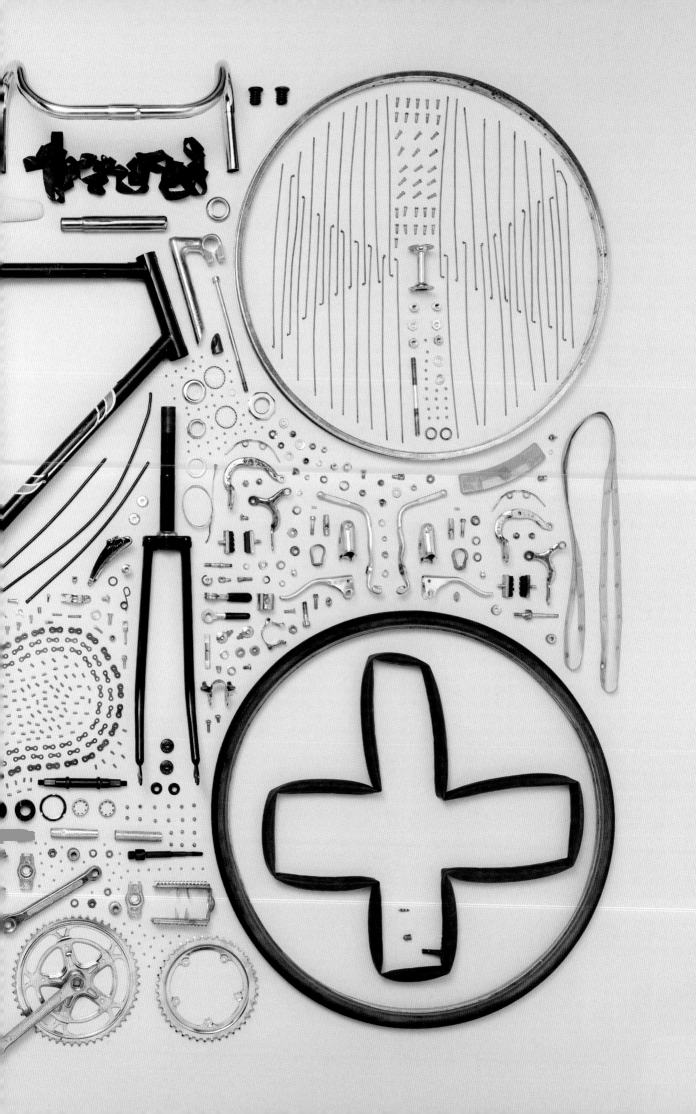

Wood Chipper, 2007

MacKissic
Component count: 502

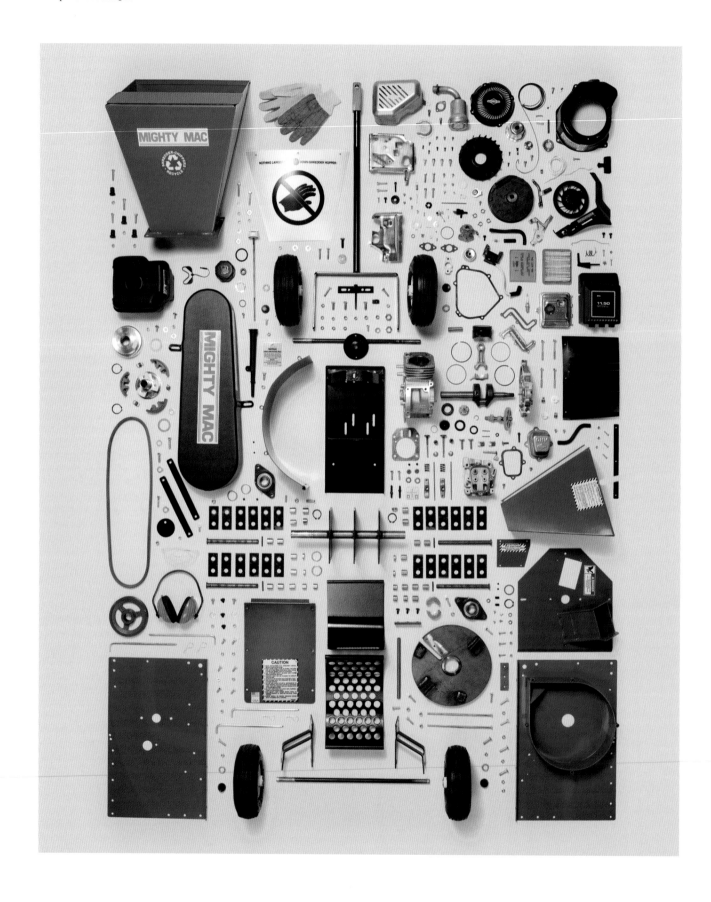

Pitching Machine, 2002

Master Pitching Machine
Component count: 644

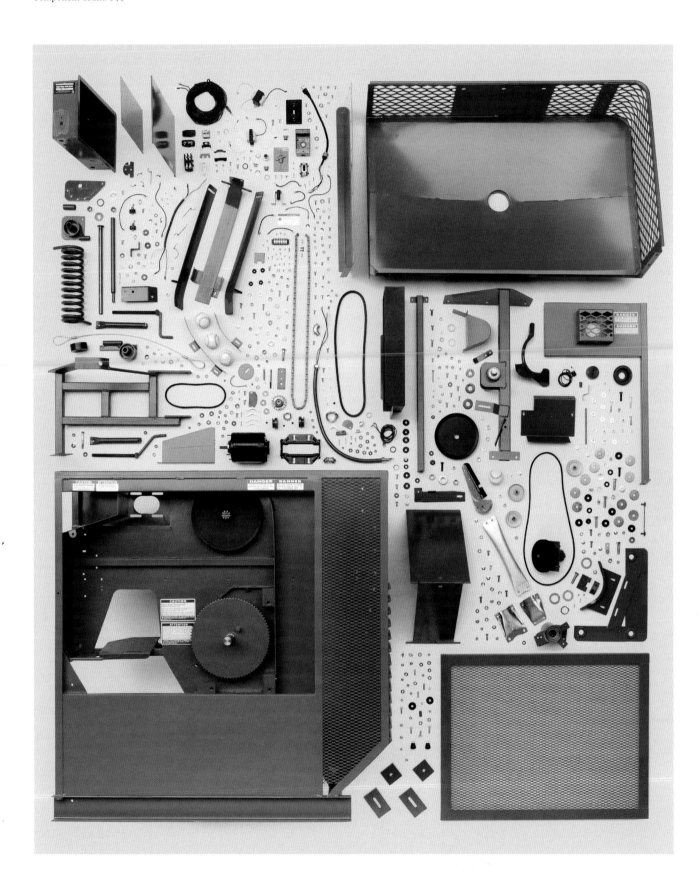

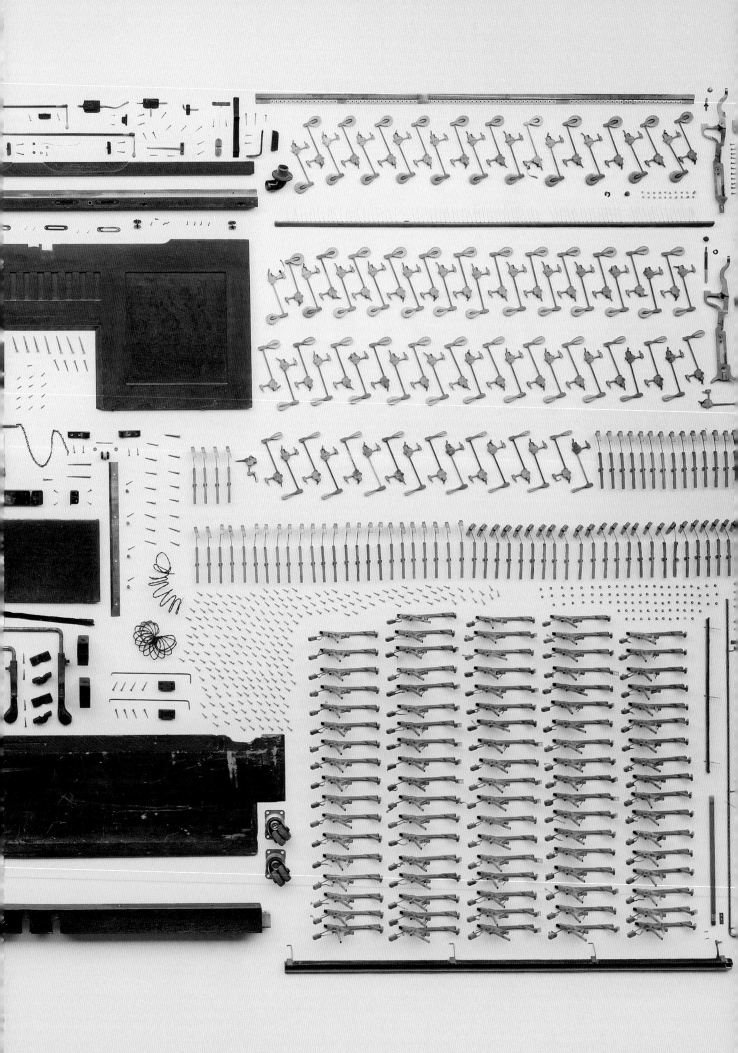

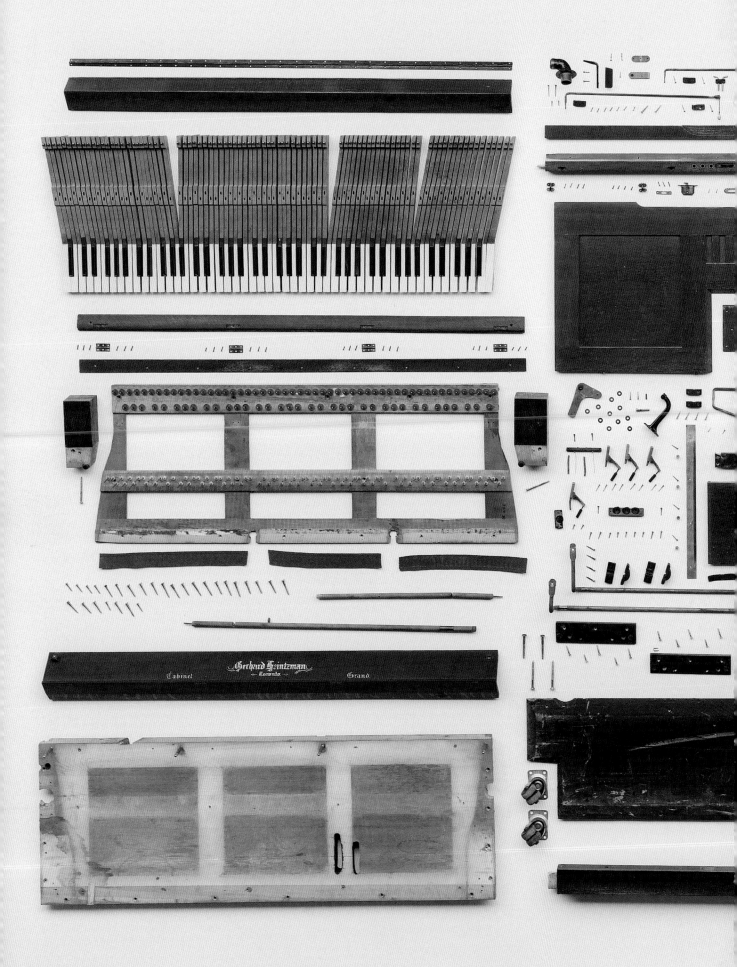

Frozen Vending Machine, 2016

Fastcorp
Component count: 1,289

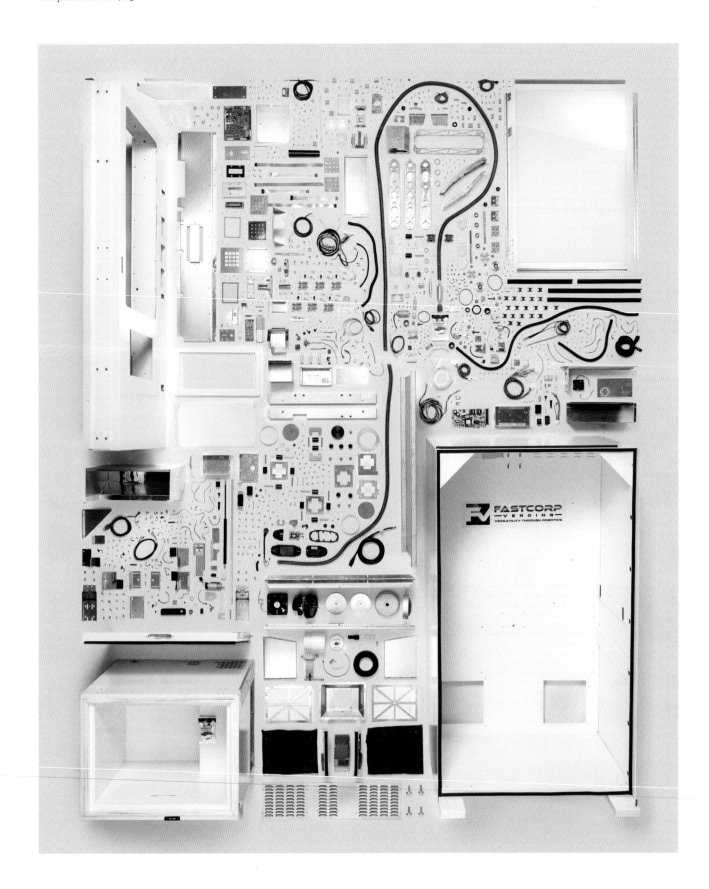

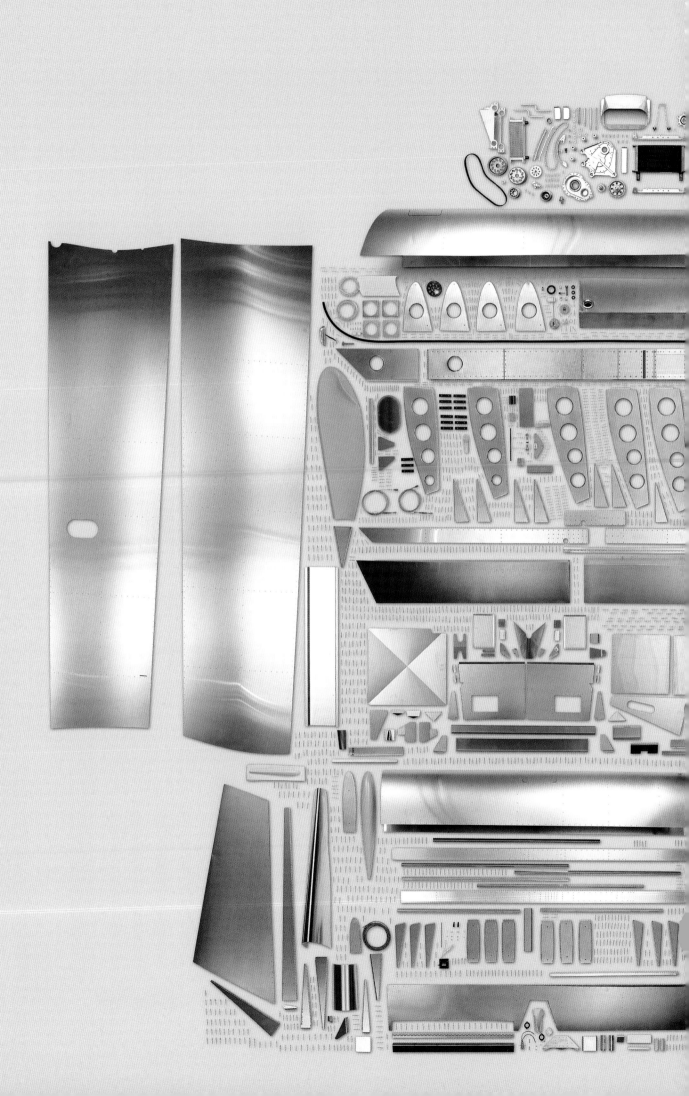

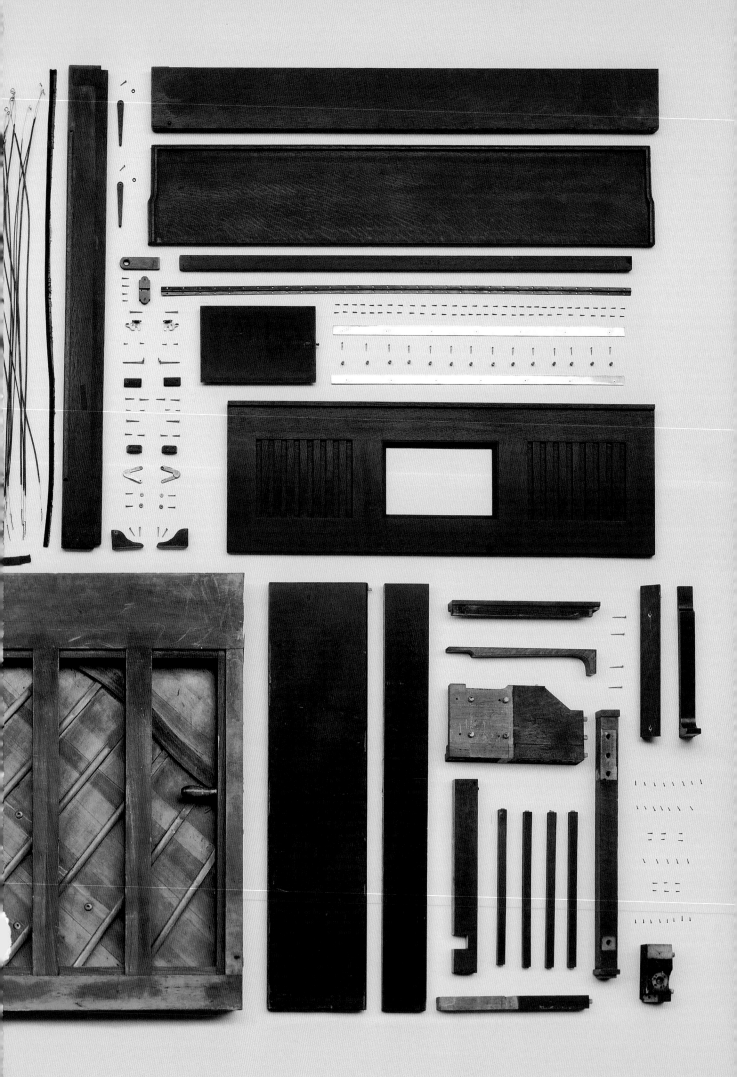

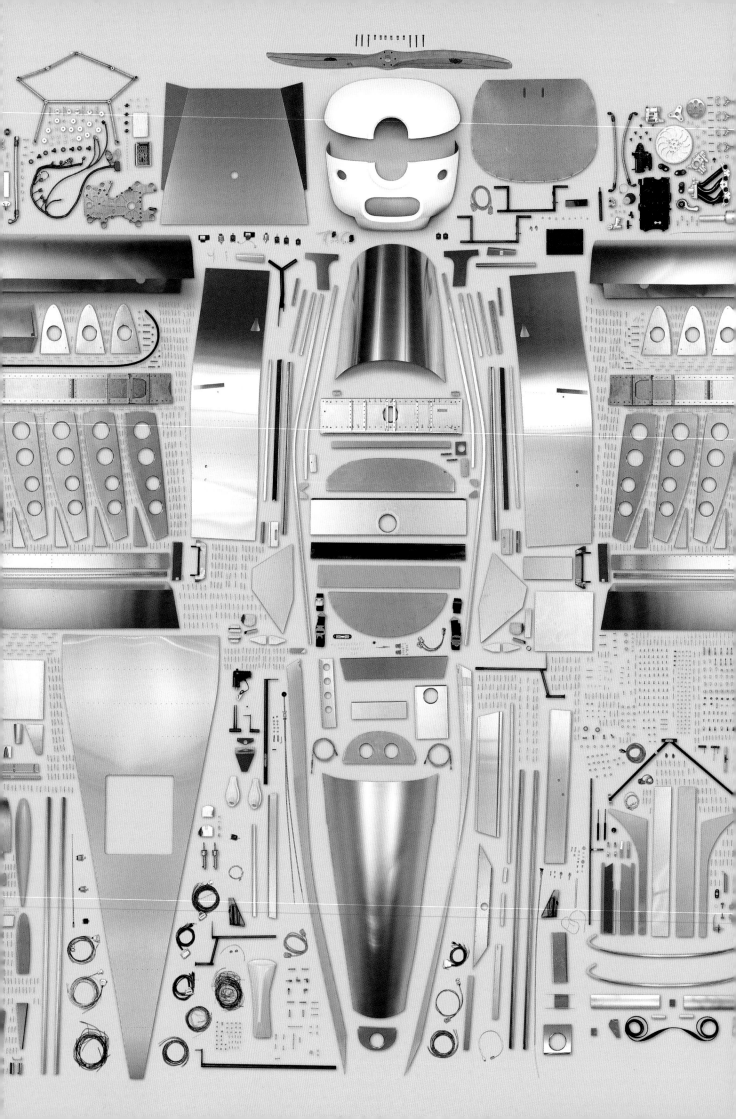

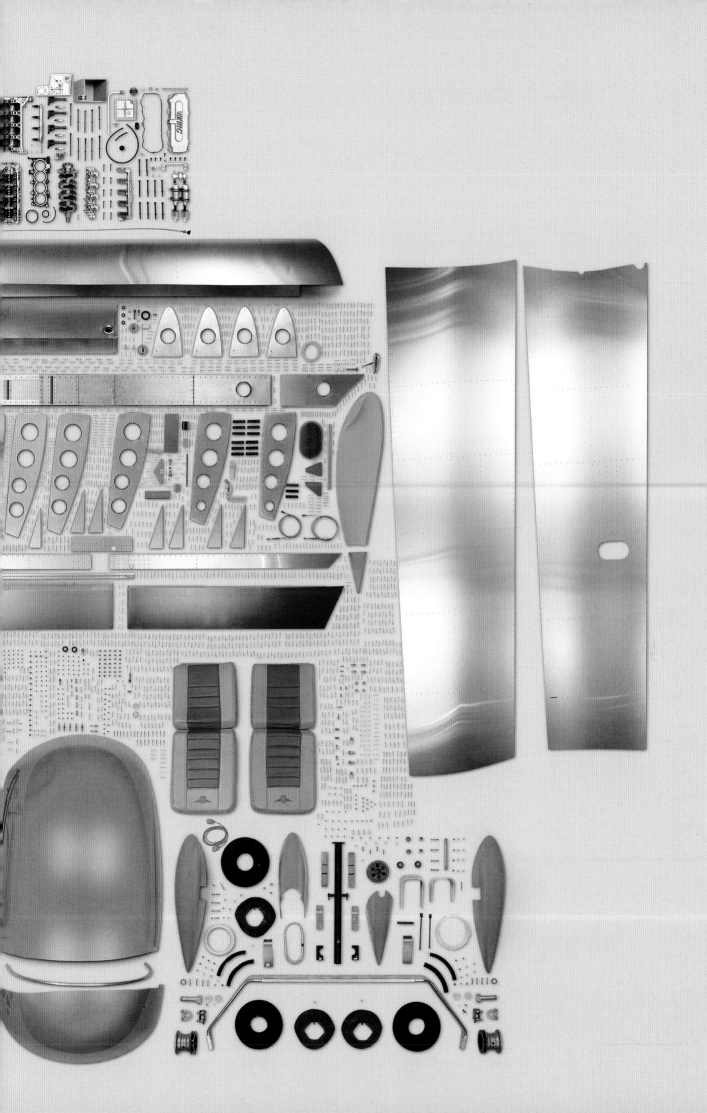

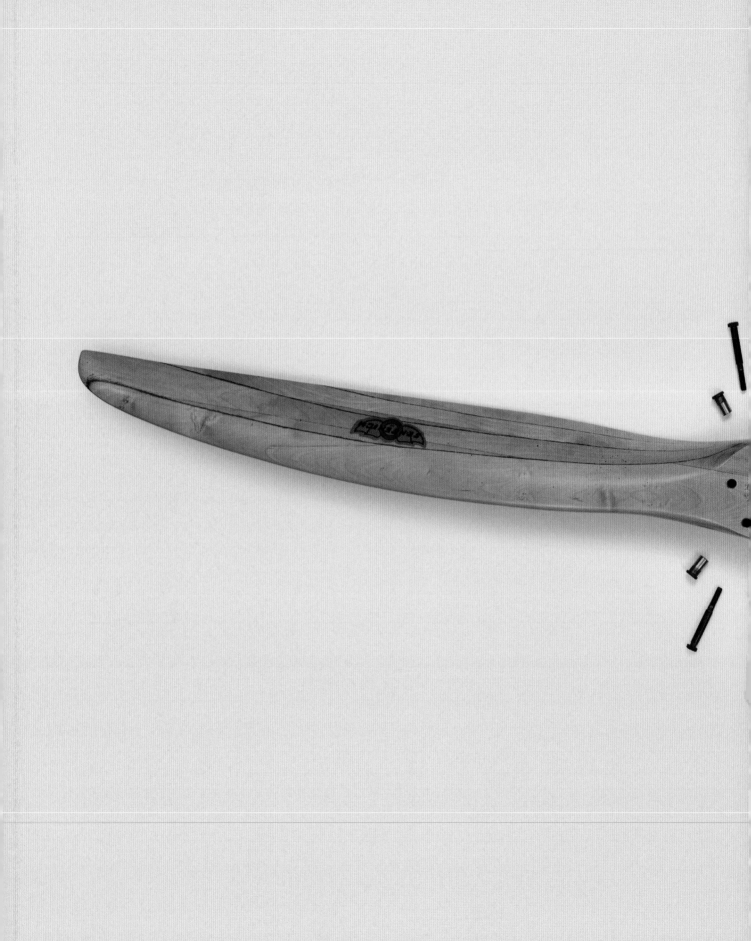

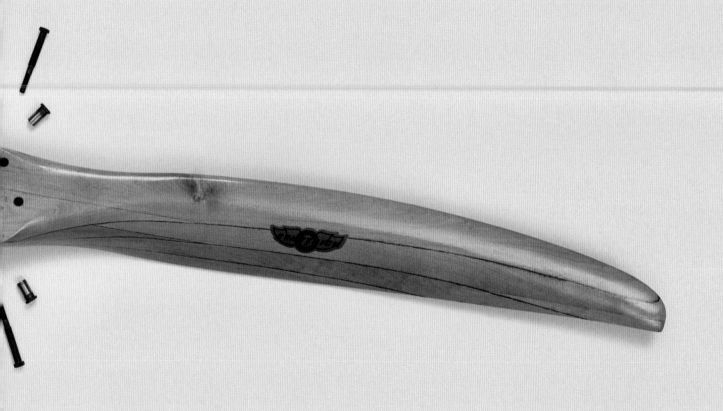

Dr Joseph Chiodo is an inventor of 'Active Disassembly' technology, products that automatically come apart when exposed to a trigger mechanism.

#4

FALLING APART: THE FUTURE

Most products are designed to be put together, not to fall apart in a controlled and environmentally useful or profitable way. When they cease to function or break apart prematurely, they become redundant. Such products designed with no consideration to what will become of them at the end of their useful lives create a cascading series of problems – they threaten environmental sustainability, they exhaust resources, and they undermine jobs and economic stability.

The risk to the environment is particularly great in the case of consumer electronic products, which contain heavy metals, toxins, contaminants, rare earth elements, and precious metals. If dumped at landfill sites, they degrade and leach hazardous elements into the ecosystem. This is in addition to the environmental cost of mining – itself powered by gigantic oil-based resources – of massive volumes of earth to obtain minerals, and the poisonous processes used to extract them.

Yet materials such as rare earth elements and precious metals are in very short supply and are much in demand for eco-technologies such as wind turbines, solar panels, hybrids, new electrical applications, and batteries. And supply is unbalanced regionally – the fact that China currently controls 97.5 percent of the world's rare earth elements presents serious supply and cost issues for alternative energy industries elsewhere. Acquisition of more commonplace resources such as oil is becoming increasingly expensive too. Even when the resources are needed for green technologies, legislation intended to protect the environment can make their cost prohibitive.

Increasing environmental and materials costs coupled with scarcity have resulted in a massive exodus of manufacturing jobs from the West to the East. While this has increased employment opportunities and living standards in Asia, it is creating alarming trends in the West. Such job migration is detrimental to the long-term prosperity of both the West and the East because affordability of goods relates closely to incomes, which in turn depend on employment.

Good stewardship of the environment, resources, and jobs is essential for profitability. If environmental quality is compromised, the long-term costs of damage, clean-up, and relocation reduce the potential for profit. Increasing scarcity of resources will eventually make manufacturing costs prohibitively high. Reduced profits and higher costs, both environmental and industrial, lead inevitably to economic decline.

But there is an alternative. Instead of scouring the earth to extract its shrinking resources, we can make more

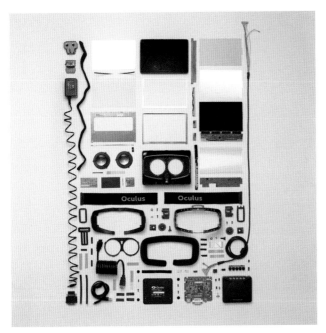

Virtual Reality Headset, 2013 | Oculus | Component count: 108

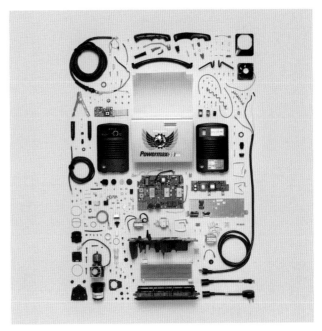

Plasma Cutter, 2008 | Hypertherm | Component count: 257

effort to reuse those already sourced. In the decade since William McDonough and Michael Braungart published their manifesto for the transformation of human industry, *Cradle to Cradle: Remaking the Way We Make Things* (2002),

> Up until now, taking products apart manually has been expensive and destructive...

significant advances have been made towards realizing their visionary new design paradigm. They describe a system that would be the opposite of 'cradle to grave' manufacturing that dates back to the Industrial Revolution, and in which as much as 90 percent of materials in any manufactured product are ultimately discarded as waste, often toxic. Instead, they propose that product designers conceive of the materials they employ as 'nutrients' that circulate over time in a sustainable and non-destructive way, as in natural life cycles. Technical or inorganic nutrients will be employed in such a way that they are reusable without loss of quality, and are no longer discarded as waste

or 'downcycled' into lesser products. Biological or organic nutrients will decompose back into the natural environment. Every new product's ultimate demise and reuse will be anticipated from the outset of the design process.

One of the key stepping stones to achieving this in practice is the design of products that will come apart or disassemble easily at the end of their useful lives. Up until now, taking products apart manually has been expensive and destructive, incurring prohibitive labour costs and a loss of component quality. But such deterrents are increasingly being overcome thanks to a new, advanced, low-unit-cost, controlled, hierarchical, mass dismantling End of Life (EoL) technology called 'Active Disassembly'.

Active Disassembly technologies take various forms. For example, Thermoplastic Hot-Melt Adhesives for Disassembly (THMAD) can be used to join together two or more surfaces of a product's casing or components. When melted through an applicator, the glue flows into cavities on the inside surfaces before cooling, hardening, and providing a strong 'grip'. THMAD has considerable strength and is much faster in its setting time than traditional solvent-based adhesives. At the end of the product's useful life, the assembly is reheated and the adhesive becomes liquid again, releasing the components.

Any remaining adhesive residue is drawn from cavities via capillary action or suction. Clean separation of the components is achieved, and in addition the glue can be reused. THMAD is potentially suited to large-scale recycling applications.

A variant of THMAD technology is Hot Wire Adhesive Release (HWAR). During manufacture, a thin wire or metallic strip is embedded within a thermoplastic hot-melt adhesive join. This wire loop has a standard electrical jack input within the assembly. When electrical current is passed through this point, the wire provides resistance and becomes hot. The heat melts the thermoplastic joint, allowing the components to be separated and recovered. To prevent damage to the product, the thermoplastic adhesive insulates the host assemblies from the heat. HWAR is useful where internal components would be damaged by exposure to high or concentrated heat. It provides a localized heating technique that is fast and flexible enough to be used on both manual and automated disassembly lines. The localized heating is energy-efficient because heat is applied only through the wire, that is, where it is needed to provide controlled disassembly.

Another form of heat-triggered Active Disassembly involves Thermally Reversible Adhesives (TRA). These

In a process known as 'training' Shape Memory Alloys can 'learn' to behave in a certain way.

provide adhesion between components and assemblies that have relatively large, flat surfaces requiring bonding or connection. As with THMAD, component disassembly is achieved by means of an external heat source, but here TRA application is in the form of a thin film, either sprayed in a fine mist or applied as a tape. The adhesive, first applied in the initial assembly, is then activated using heat or ultrasound. On disassembly, the mist or tape is easily removed from components and recycled, and

the disassembled components are cleaned of residue to prevent contamination of the recycled elements.

A further type of Active Disassembly technology consists of Shape Memory Alloys (SMA). These are materials that can 'remember' two different shapes, one at a low temperature, and one at a high temperature. The transformation in shape is due to a rearrangement of crystal structures within the solid. In a process known as 'training', SMAs can 'learn' to behave in a certain way. Normally, an SMA alloy 'remembers' its high-temperature shape, and upon heating immediately 'forgets' the low-temperature shape. However, it can be 'trained' to retain some 'reminders' of its former low-temperature condition in high-temperature phases. Usually SMAs are available in the standard form of strips, springs, or wires, but they can be moulded into any shape required. Unlike other Active Disassembly technologies, SMA when heated can provide extremely high active forces of disassembly.

Related to SMA are Shape Memory Polymers (SMP). SMP components such as one-way or reversible snap-fit fasteners and mouldings are very versatile and can be moulded either as discrete components or integrated into assembly components. They are a relatively low-cost method of Active Disassembly. Injection-moulded SMP snap components may be trained to adopt a secondary shape by being exposed to temperatures above their glass transition temperature (Tg). The SMP devices are then cooled well below their Tg, effectively 'setting' their secondary shape and making them ready for insertion into a product assembly. When it is time for EoL disassembly, the product is again heated and the SMP fasteners revert back to their original injection-moulded shape, triggering a release. The fastener may, for example, be a hook-profiled component releasing its grip from a cavity. SMP fasteners are easily inserted and removed, reducing assembly and disassembly times.

Most Active Disassembly snap-fit fasteners have so far consisted of discrete components injection-moulded using very specific SMPs that offer excellent shape recovery. While some apply no forces in their amorphous

shape change, others offer relatively strong forces to aid disassembly. Yet some SMPs remain expensive, despite price decreases over the last two decades. Fortunately, many Standard Engineering Polymers (SEP), including acrylonitrile butadiene styrene (ABS) and polycarbonates, are capable of shape memory changes similar to those of SMP, even though their shape change is less obvious and not as quick as specifically engineered SMPs.

The recycling is also...
less damaging, so the value
of the disassembled component
parts can be vastly improved.

Recent developments in Active Disassembly technology have centred on the inclusion of snap-fit fasteners in assembled components. Designed as integral parts of the components, these can facilitate both assembly and disassembly equally. For this to be possible, the integral snap-fit fasteners are 'trained' within the injection mould tool itself. They are trained in such a way that stresses are formed within the mould. Subjected to their trigger temperature, these integral SEP components display a shape memory that may be considered as a controlled form of creep or deformation. Because the integral snap-fit fasteners are moulded within the same polymer component that makes up the rest of the housing, assembly and disassembly times are potentially reduced. The recycling is also more efficient and less damaging, so the value of the disassembled component parts can be vastly improved.

While the Active Disassembly processes described so far are triggered by heat, Active Disassembly using Biodegradable Composites (ADBC) is triggered by chemicals, water, or exposure to heavy humidity. (In natural environments of extreme humidity, premature degrading of functioning ADBC components can be prevented by applying a non-water-soluble coating that is easily removed with chemicals or steam at the beginning of the recycling

process.) ADBC is a very efficient, extremely quick, and ecologically sensitive technique for disassembling and separating components from printed circuit boards (PCBs). Active biological layers include starch, gelatin, or plant extracts, and the layers can be substrates of the PCB itself. During disassembly, the layers enable the board to be broken apart with the addition of water or chemicals, depending on the material employed. At the end of the disassembly procedure, the components left behind are easily sorted, reused, and recycled. The remaining biodegradable substrate material can then be treated within a bio-reactor to achieve quick decomposition and extract small amounts of copper, rare earth elements, or precious metals for recycling.

A common current EoL practice is to shred electronic components and process the resulting particles through a variety of mechanical separation techniques. However, such methods reduce the value of the recycled output. The use of biodegradable elements allows integrated chips and other components to fall away intact while the substrate dissolves. Because the chips and components emerge in a more valuable state for reuse – and metal yields can be very high – manufacturing companies have a much greater incentive to recycle, while remanufacturers, repairers, and the refurbishing industry secure high-quality components for re-entry into the product market.

Without a doubt, Active Disassembly technologies have a potentially huge role in preserving the environment, conserving resources, promoting employment, and safeguarding the world economy.

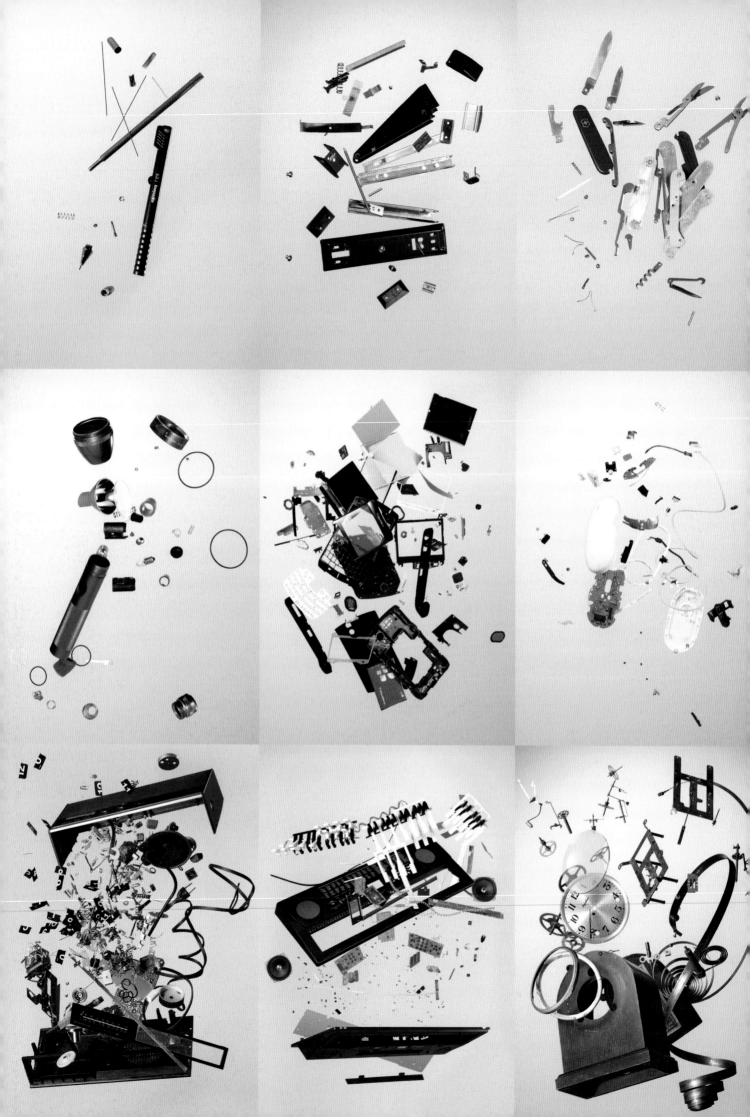

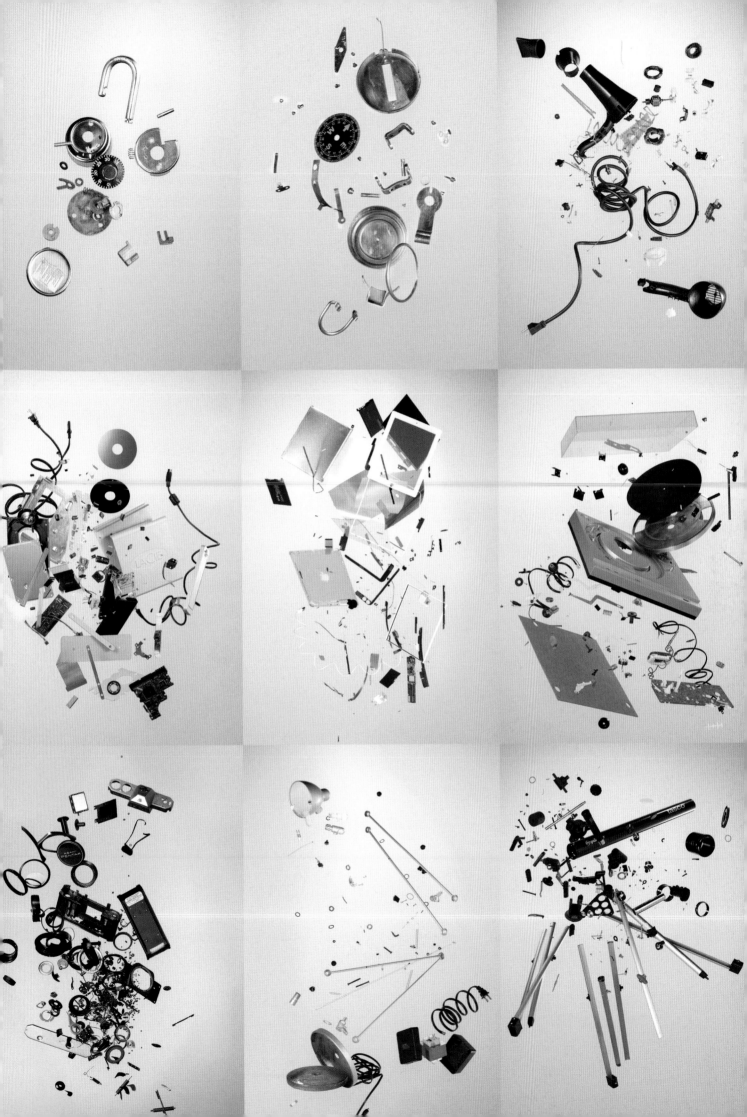

INDEX OF THINGS

ACKNOWLEDGMENTS

I would like to thank my wife Barb and my children Devon & Morgan for accepting my obsession and the many hours that I have put into these photographs.

A special thank you to Tristan de Lancey and to everyone involved at Thames & Hudson for hunting me down and for welding the project into a book.

Thank you to Sugino Studio and the team for their support and space to shoot, and especially to Shinjiro for assisting me with almost every frame of the book: dropping mountains of pieces on set is no easy task.

And of course thank you to all the people who create such wonderfully designed objects, new and old.

Todd McLellan

Prints from this book are available through toddmclellan.com

On the jacket:
Macintosh Computer, 1990 | Apple | Component count: 928
Typewriter, 1964 | Smith-Corona | Component count: 621

On the cover boards:
Front: Ceiling Fan, 2014 | Big Ass Fans | Component count: 149
Back: Chainsaw, 2010 | Stihl | Component count: 297

Pages 2 and 4: Fire Extinguisher, 1999 | Pyrene | Component count: 28
Page 6: Transistor Radio, 1967 | Panasonic | Component count: 199
Page 7: Cordless Phone, 2004 | Panasonic | Component count: 111
Page 8: Rotary Telephone, 1980s | Northern Electric | Component count: 148
Page 9: Flip Clock, 1970s | Sanyo | Component count: 426.